XU BING: Tobacco Project

Duke | Shanghai | Virginia, 1999–2011

XU BING: Tobacco Project

Duke | Shanghai | Virginia, 1999–2011

John B. Ravenal

With essays by Wu Hung, Lydia H. Liu,
and Edward D. Melillo

VMFA

Virginia Museum of Fine Arts, Richmond

Distributed by the University of Virginia Press,
Charlottesville and London

This publication accompanies the exhibition *Xu Bing: Tobacco Project,* presented at the Virginia Museum of Fine Arts, Richmond, from September 10 through December 4, 2011.

The exhibition travels to the Aldrich Contemporary Art Museum, Ridgefield, Connecticut, opening on January 30 and remaining on view through May 28, 2012.

This exhibition and publication were supported by Carolyn Hsu-Balcer and René Balcer.

Library of Congress Cataloging-in-Publication Data
Ravenal, John B., 1959–
 Xu Bing : Tobacco Project, Duke/Shanghai/Virginia, 1999–2011 / John B. Ravenal ; with essays by Wu Hung, Lydia H. Liu, and Edward D. Melillo.
 p. cm.
 Published to accompany an exhibition held at the Virginia Museum of Fine Arts, Richmond, Va., Sept. 10–Dec. 4, 2011.
 Includes index.
 ISBN 978-0-917046-96-4 (alk. paper)
 1. Xu, Bing, 1955– Tobacco project—Exhibitions. 2. Site-specific installations (Art)—Exhbitions. 3. Tobacco in art—Exhibitions. I. Xu, Bing, 1955– II. Wu Hung, 1945– III. Liu, Lydia He. IV. Melillo, Edward D. V. Virginia Museum of Fine Arts. VI. Title. VII. Title: Tobacco Project, Duke/Shanghai/Virginia, 1999–2011.
 N7349.X8A76 2011
 709.04'074—dc23 2011029514

Editor in Chief: Rosalie West
Project Editor: Reiko Tomii
Index: Anne Adkins and Kathleen M. Friello
Designer: Kenny Kane
Photographer: Travis Fullerton

Printed on Sappi McCoy Silk by Worth Higgins & Associates, Inc., Richmond, Virginia
Composed in Adobe InDesign with Minion Pro and Helvetica Condensed

Cover: Detail of *1st Class* (cat. no. 1)
Frontispiece: Detail of *Light as Smoke* (cat. no. 4)

Virginia Museum of Fine Arts
200 N. Boulevard
Richmond, VA 23220
www.VMFA.museum

Contents

Foreword

Serving the Commonwealth of Virginia by presenting the finest art from around the world has always been the goal of the Virginia Museum of Fine Arts, and since our historic expansion and reopening in 2010, we have extended our reach in new and wonderful directions. Xu Bing's *Tobacco Project* extends that reach as far as China and as close as Virginia, allowing us to explore their shared history and address Virginia's place in the world in a wholly unexpected way.

The relationship between Virginia and tobacco is inescapable; indeed the site of the Virginia Museum of Fine Arts was surrounded by tobacco fields until the early years of the twentieth century. Xu Bing's inspired layering of the history, culture, and materials of tobacco widens our perspective on a topic that has become mundane yet highly politicized. Xu Bing does not take an obvious subjective stance but, like all great artists, forces us to look with fresh eyes.

As a collaborative artist, Xu Bing has a special appreciation for the varied talents and skills of people who make things happen. I know he joins me in thanking John Ravenal, Sydney and Frances Lewis Family Curator of Modern and Contemporary Art, Carolyn Hsu-Balcer and René Balcer, and the many other individuals who have been involved with *Tobacco Project* at the Virginia Museum of Fine Arts and helped to realize the remarkable creative gifts and vision of Xu Bing. It has been an unforgettable experience for all of us.

Alex Nyerges
Director
Virginia Museum of Fine Arts

烧不下去了
那心里有障碍
这是钉了钉子

九三毛二〇〇
〇上三十元
海水

Acknowledgments

Xu Bing always conceived of *Tobacco Project* as having multiple iterations. After the first version at Duke University in Durham, North Carolina, he envisaged a follow-up exhibition in Shanghai, where W. Duke, Sons & Company had their headquarters. This took place in 2004, and soon after, he proposed an exhibition at the Virginia Museum of Fine Arts. Collector and former VMFA trustee Carolyn Hsu-Balcer had approached Xu Bing about making a tobacco-themed painting to give to the museum on the occasion of its planned expansion. She was already involved with VMFA through the gift with her husband, René Balcer, of some 330 woodblock prints by Kawase Hasui. The gift of a Xu Bing painting was also meant to honor the memory of her paternal grandfather, Zee Tsun Yee, who had done business with Universal Leaf Tobacco Company in Shanghai starting in the late 1920s. He had become close friends with James Covington, who was later chairman of Universal Leaf as well as guardian and mentor to Carolyn's father, Yuan Kan Hsu, when he was sent to Richmond to finish high school and learn the tobacco trade. Rather than make a commissioned painting, Xu Bing proposed an exhibition. Both Carolyn and René deserve special appreciation for their role in helping initiate the Virginia *Tobacco Project* and for their support in realizing the exhibition, publication, and symposium.

I am pleased that the exhibition will travel to the Aldrich Contemporary Art Museum, where former Director Harry Philbrick arranged to exhibit the project, and Richard Klein, Exhibitions Director, capably followed through.

Above all, I wish to offer my deepest appreciation to Xu Bing himself. It was an honor and privilege to work closely with him on this exhibition and publication. He is an uncommonly wise artist whose large vision grows out of detailed observation, and he has brought an international perspective to a distinctly Virginia subject—tobacco. In this process, he has taught us something not only about our own history, but about our capacity as a museum to realize an ambitious context-specific project involving an artist's residency and extensive research. We are grateful to him for his generous partnership.

The Virginia *Tobacco Project* has been a complex project involving many people in diverse capacities. Xu Bing's studios in New York and Beijing played a central role. In particular, Jesse Robert Coffino, studio director, participated in every aspect of planning and has tirelessly answered questions, found solutions, and played a hands-on role in fabricating work. Yao Xin, Xu Bing's studio assistant, was also very helpful in providing information and in making the residency a success. I also thank Casey Tang and Xu Hong in New York, and Lu Xin, Xue Feng, and Xu Yan in Beijing.

Xu Bing's residency was organized as a collaboration with the Virginia Commonwealth University (VCU) School of the Arts. I am grateful to department chairs Sonya Clark, Amy Hauft, and Holly Morrison. Special appreciation is due to the eight former VCU School of the Arts students who served as assistants during and after Xu Bing's residency in Richmond:

Nicole Andreoni, Amy Chan, Andrea Donnelly, Jillian Dy, Michael Muelhaupt, Yi Sheng, Sayaka Suzuki, and Jill Zevenbergen. They labored many hours making pieces for the exhibition, impressing Xu Bing with their skills and work ethic. Jon-Phillip Sheridan, also at VCU, organized a cadre of student photographers to document the project: Kimberly Burgess, Eric Carlson, Tony Hall, Kathleen Jones, Harrison Moenich, Kevin Murphy, Diego Valdez, and Mark Waldhauser. Miriam Ewers helped with some of the printing. VCU professors Ruth Bolduan, Elizabeth King, and Carlton Newton generously hosted Xu Bing during his stay in Richmond.

The artist was warmly received by several current and former Virginia tobacco farmers and their families who generously shared with him their expertise: Julian and Edwina Covington, near Elam; Daniel Glenn Jr. and Larry Allen, both in Prospect; and Carl Parsons, in Chatham.

The project required specific tobacco-related materials, which were assembled thanks to several people. Marvin Cogshill generously arranged for contributions and discounted purchases of whole leaves, compressed tobacco, reconstituted leaf sheet, and cigarettes. Phil James of Mundet International supplied cigarette paper and tipping paper. William J. Gouldin Jr. and William J. Gouldin III at Strange's Florists, Greenhouses and Garden Centers grew the live tobacco plants for *Nature's Contribution*. The forty-foot-long cigarette for *Traveling Down the River* was provided by Andy Shango and Mike Spissu at East Carolina RYO, together with Rusty Blackwell at U.S. Tobacco Cooperative and John Taylor at U.S. Flue-Cured Tobacco Growers.

Xu Bing's research, as well as mine, was facilitated by a number of colleagues at other local and regional institutions who were gracious with their time and knowledge: William J. Martin, Megan Glass Hughes, Suzanne Savery, and Autumn Reinhardt Simpson, Valentine Richmond History Center; Thomas Camden, Conley L. Edwards III, and Dale Neighbors, Library of Virginia; William M. S. Rasmussen, Virginia Historical Society; Christopher D. Jones, Robert Morris, Gary Grant, and J. Dan Shaw, the Prizery; Gary Hutcherson and Angela Hancock, Reynolds Packaging; David Redmond, Carolina Tobacco; Deborah L. Cannon, Northern Virginia Tax Board; John D. Gibbs, C & M Baling Systems, Inc.; James Ingraham, Virginia Department of Taxation; Dale Coats, North Carolina Historic Sites; Jennifer Farley, Duke Homestead; and Stephen Klepper, Lorillard Tobacco Company.

Several others also contributed to the project. Joe Griffin created a documentary film that premiered at VMFA's weekend symposium, "Universal Language: Xu Bing and the Vocabulary of Tobacco." John and Maggie Hager hosted Xu Bing at their home. Mr. and Mrs. Yuan Kan Hsu, Carolyn's parents, provided hospitality. Rachel Shen provided images from the Shanghai Gallery of Art. Stacy Farinholt helped obtain branches for *Match Flower*. Bob Cage contributed valuable historical information about the tobacco business. Josh Eckhardt in the VCU English Department identified and supplied a copy of the passage used in *Tobacco Book*.

The project would have been incomplete without a scholarly catalogue. The guest authors who contributed to the publication—Wu Hung, Lydia H. Liu, and Edward D. Melillo—deserve special mention. Their scholarship has greatly enhanced the project. Guest Project Editor Reiko Tomii deserves high praise for her role in shepherding the publication to completion. An accomplished scholar, she has also served as editor for many important publications and her expertise contributed greatly to the success of this project. She was assisted by Kathleen M. Friello. Reiko also served as coordinator for the weekend symposium that took place at the exhibition's opening in Richmond. We are honored to have University of Virginia Press as our publication partner, distributing this volume as the latest of our collaborations.

Numerous VMFA staff were essential to the success of *Tobacco Project*. Director Alex Nyerges showed great enthusiasm from the beginning, and his support is deeply appreciated. Robin Nicholson, Deputy Director for Art and Education and Head of Exhibitions, handled the complexities of the project with his usual aplomb. He was assisted by Aiesha Halstead and Courtney Burkhardt. Stephen Bonadies, Deputy Director for Collections and Facilities Management, was also instrumental in helping realize the exhibition. In my department, Sarah Eckhardt, Assistant Curator of Modern and Contemporary Art, and intern Laura Keller provided valuable assistance; Laura deserves special mention for her diligent research. For the production of this beautiful catalogue, I offer sincere appreciation to my talented and indefatigable colleagues in the Publications Department: special recognition is due to Sarah Lavicka, Chief Graphic Designer and Acting Manager; Rosalie West, Editor in Chief; Stacy Moore, Editor; Kenny Kane, Graphic Designer; and Libby Causey-Hicks, Publications Marketing Representative. In the Department of Education and Statewide Programs, Celeste Fetta, Della Watkins, and Sandy Rusak ably coordinated the weekend symposium. The photography for this exhibition was admirably handled by Travis Fullerton, Acting Manager of Photography and Museum Photographer, and Susie Rock, Coordinator of Photography. Howell Perkins obtained numerous images and photographic rights. The tracking, packing, and shipping of the exhibition was superbly managed by Kelly Burrow, Megan Zeoli, and Justin Brown, among others in the Registration Department. Bob Tarren and Suzanne Hall coordinated marketing and publicity efforts, including an off-site press event in New York, organized by Suzanne. Tom Baker helped design the exhibition. Anne Barriault worked with me to prepare grant proposals. David Bradley, Deputy Director for VMFA Foundation Administration and Government Relations, kindly helped resolve several complex issues.

As ever, I offer gratitude to my family, Ginny, Eva, and Daniel, for their forbearance.

John B. Ravenal
Sydney and Frances Lewis Curator of Modern and Contemporary Art

care will returne him both clothes and oth
er necessaries. For the goodnesse where o
answerable to est-Indie Trinidado or Cra
(admit there hath no such bin returned) le
no man doubt. Into the discourse whereo
ince I am obviously entred, I may not forg
he gentleman, worthie of much commer
lations, which first tooke the pains to mak
rial thereof, his name Mr. John Rolfe, Anno
Domini 1612 partly for the love he hath
ong time borne into it, and partly to rais
ommodit to the adventurers, in whole bet
lfe I witnes and vouchsafe to holde my tes
non in beleef, that during the time of thi
broate there, which draweth neere upons
eers, no man hath labored to his power
y good example there and worth incour
rement into England by his letters, it en

Tobacco as a Universal Language

John B. Ravenal

Figure 1.1
Book from the Sky (detail), 1987–91
A boxed set with four volumes of woodblock books
Each book: 18 1/8 x 11 3/4 in. (46 x 30 cm)

One of China's most acclaimed contemporary artists, Xu Bing is closely identified with language and printmaking—often joining the two to produce spectacular installations. Xu Bing[1] first gained widespread attention for *Book from the Sky* (1987–91; figures 1.1, 2.1), a room-size environment of hanging scrolls, wall panels, and bound books printed using more than four thousand wooden blocks carved with his newly invented written symbols that resemble Chinese characters but are actually unintelligible. Viewers trying to decipher the texts encounter nonsense: nonsense on a monumental scale, presented in traditional forms, and carried out with extreme dedication. When first exhibited in Beijing in 1988 and again in 1989, the work caused a sensation—variously confusing, inspiring, and offending its audience, many of whom rightly understood its negation of meaning as a critique of both the traditional values of Chinese culture and the Communist Party's manipulation of written language.

In *Tobacco Project*, Xu Bing extends his interrogation of language, taking tobacco as his subject and medium (figure 1.2). He uses whole leaves as the support for a printed text about the early cultivation of tobacco in Virginia. He embosses words from a cigarette slogan onto a compressed block of tobacco. And he adapts historical tobacco graphics and advertisements to make a book printed on sheets of cigarette paper. Even more fundamental than this interest in printed words and graphic design is the way in which Xu Bing approaches his entire subject as a universal language, seeing the culture of tobacco as a far-reaching system of signs and symbols embodied in all manner of images, objects, and behavior. The works he produces in response treat tobacco as a text: not a literal piece of writing—though that, too, is part of the work—but a piece of social material whose underlying codes connect to broader myths and meanings.

Detail of *Tobacco Book* (Virginia version; cat. no. 3)

13

Xu Bing's semiotic approach should be understood as a creative position. *Tobacco Project* is not a scholarly analysis that draws conclusions or proposes actions. Rather, tobacco engages Xu Bing on many levels at once, allowing him to raise questions, make new connections, and expand his viewers' awareness. Above all, he sees it as a medium of cross-cultural exchange, which first connected Virginia and other former colonies of the Americas to Europe and other parts of the world in the age of discovery and continues to provide a connective thread in the age of globalism. In addition, he appreciates tobacco's unique set of formal properties. *Tobacco Project* appeals to the sense of not only sight but smell, and Xu Bing was conscious of permeating the gallery with the rich, sweet odor of tobacco. He also made pieces that embody tobacco's full physical trajectory, from leafy and green to brittle and brown to smoke and ash. Other works feature the materials and paraphernalia associated with tobacco consumption, including pipes, papers, matches, and ashtrays. Moreover, the commercial visual culture of tobacco, with its large repertoire of packaging and advertising designs, offers fertile ground for exploration.

Tobacco Project also underscores the versatility of Xu Bing's creative process. He takes a conceptual approach to his work, prioritizing the idea rather than personal style or self-expression. Consequently, he often begins with extensive research and frequently involves collaborators—specialists, students, volunteers, and assistants—whose participation helps open up the conventional notion of individual creation to a more collective model. Paradoxically, Xu Bing's conceptual approach stems in part from his virtuosity in calligraphy and printmaking. His early interest in letters, type forms, and written text steeped him in the idea of language as a basis of artistic practice. While this grounded him in ancient Chinese traditions, it also made him receptive to currents of international contemporary art that incorporated words and phrases into paintings, presented texts alone as visual art, or used written instructions as the basis for making work. This language-based conceptual art was one of a number of Western artistic and intellectual influences that washed over China following the end of the Cultural Revolution after Mao's death in 1976. Dada was another strong influence on the Chinese avant-garde and, like conceptual art, involved a self-reflexive and subversive stance, questioning the nature of the art object and the art institution. This dovetailed with certain East Asian philosophical and artistic traditions, including Zen Buddhism and the practice of master calligraphers who would manipulate established characters to create new forms and meaning. Synthesizing diverse influences and joining their lessons to his own analytical tendencies, Xu Bing developed an unorthodox approach that takes as a central goal to shake viewers from entrenched habits of viewing and thinking. In addition, he developed a relationship to tradition that combines parody and respect in equal measure, leading one noted scholar to dub him a "quiet iconoclast."[2]

Xu Bing's research-based approach opens him to the possibilities inherent in each new situation, often resulting in the creation of site-specific or site-responsive work—that is, work that exists only within one context or work that incorporates aspects of the context into

its forms or meanings. *Tobacco Project* grew out of Xu Bing's visits to Duke University in Durham, North Carolina.[3] Through trips to farms, factories, and historical sites, coupled with archival research and reading, he came to understand the deep bond that existed between the Duke family, the university they founded, the city, and the tobacco industry, and he conceived of a project informed by this web of connections. Xu Bing also had a personal connection to tobacco. In 1989, at the age of 64, his father died from lung cancer, a disease that progressed very quickly following the initial diagnosis. Making this association public, Xu Bing projected his father's medical records onto one of the outside walls of an old tobacco-drying barn at the Duke Homestead, accompanied by a recorded English translation (figure 2.8). In subsequent installations in Shanghai and Virginia, he displayed the actual medical records (cat. no. 33), discreetly incorporating his personal and tragic connection to tobacco.

Figure 1.2 Xu Bing at Carl Parsons's farm, Chatham, Virginia, August 2009

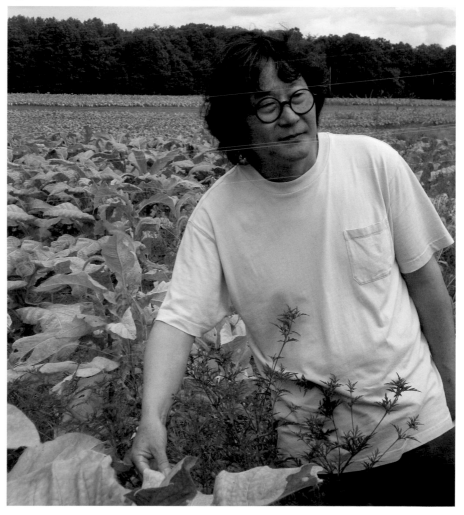

In 1905 the British American Tobacco Company, a joint venture largely run by the Duke family, was the first foreign cigarette maker to set up shop in China, and their operations remain among the most profitable foreign-business ventures ever launched there. The pervasive and, until recently, largely unregulated use of tobacco that they helped introduce should also be considered as a wider backdrop for Xu Bing's interest in the subject. China produces and consumes more than a third of the world's tobacco.[4] According to reports from the Center for Disease Control and the World Health Organization, more than three hundred million Chinese smoke—roughly equivalent to the entire population of the United States—a figure that includes more than half of all Chinese men.[5] Not surprisingly, tobacco plays a prominent role in daily social interaction. It is customary to give cigarettes when meeting new friends or visiting relatives, attending weddings and holiday celebrations, thanking doctors, or bribing officials. These social aspects have also entered Xu Bing's work along with formal, historical, political, and personal dimensions. As Xu Bing devised his own visual commentaries, he has positioned his subject as a paradigm of innovation, exploitation, and self-contradiction.

Figure 1.3 Xu Bing inspecting flue-cured tobacco at Carl Parsons's farm, Chatham, Virginia, August 2009

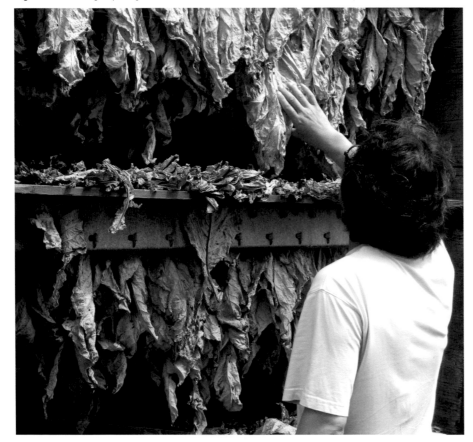

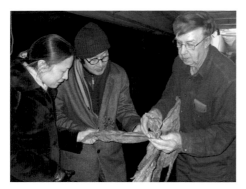

Figure 1.4
Julian Covington (right) showing air-cured tobacco to Xu Bing (center) and Carolyn Hsu-Balcer (left), Sleepy Hollow Acres, Elam, Virginia, February 2008

Figure 1.5
Xu Bing looking at equipment with Daniel Glenn Jr., Prospect, Virginia, February 2008

Xu Bing in Virginia

The Virginia *Tobacco Project* forms the third part in what Xu Bing now considers a trilogy. It builds on the preceding two projects by incorporating existing works and adding new ones, just as the exhibition at the Shanghai Gallery of Art (2004) built on the one at Duke University (2000). Xu Bing knew from the beginning that *Tobacco Project* would extend beyond Duke. As he learned about the historical connection between the Duke family and China, he quickly conceived of a follow-up project in Shanghai, the Chinese headquarters of W. Duke, Sons & Company.[6] The notion of Virginia as a third venue arose shortly after the Shanghai show, in response to a suggestion by a Virginia Museum of Fine Arts trustee[7] of Chinese heritage with family ties to tobacco.

Given the vital role of research in Xu Bing's creative process, it is not surprising that he visited Virginia four times while preparing the exhibition and publication (see Timeline, pages 28–29). The first three visits, in 2007, 2008, and 2009, were principally field trips to tobacco-related facilities, including farms, historical museums, and a cigarette factory. The farms were located two to three hours southwest of Richmond in Southside Virginia, a major tobacco-producing region traditionally defined as east of the Blue Ridge Mountains and south of the James River. The visits were timed to coincide with key phases in the farming cycle. Xu Bing saw seedlings germinating in greenhouses and mature fields ready for harvesting. He learned that most Virginia tobacco, especially in Southside, is bright leaf—a mild variety harvested a few leaves at a time from the bottom of the plant up. And he saw the postharvest processes of air-curing and flue-curing; in the latter, the leaves are tied in small bundles and baked slowly and evenly in airtight barns heated by propane burners until they turn a golden color (figures 1.3–1.4).

Xu Bing has a genuine interest in agricultural production and a great respect for farmers (figure 1.5). This stems in part from his experience during the Cultural Revolution, when, like many young people, he was removed from his family and sent to live in the countryside as part of Mao's rustication program.[8] His Virginia visits schooled him in the traditions and methods of tobacco farming, and also in the nearly insurmountable challenges facing owners of small and mid-size farms due to the reduced demand for Virginia tobacco—a situation created by increased consumer costs from legal settlements, decreasing rates of domestic smoking, use of cheap foreign tobacco, and changes in government price supports for planters.

In addition to his interest in agriculture, Xu Bing also has a fascination for industrial manufacturing. As he describes it, "Whenever I go to a new place the one thing I want to do most is to visit local factories. I like those machines with clever and flawless design. There is always a reason and a function behind any components, which look more like art than any installation."[9] In Richmond, Xu Bing visited the Philip Morris Manufacturing Center, where a guide conducted a tour around the massive facility—six connected buildings that cover a total of forty-three acres, equaling 1.6 million square feet. The plant uses

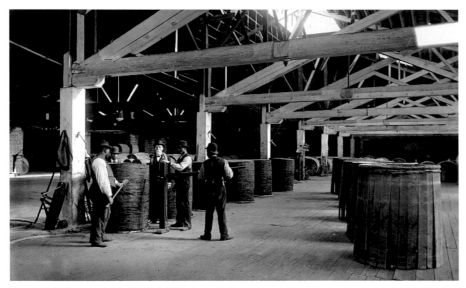

Figure 1.6 Men opening hogsheads in the early twentieth century

state-of-the-art automated production to manufacture some 150 billion cigarettes a year. Xu Bing was intrigued by this process, which includes reclaiming every stray particle of tobacco and reconstituting it into leaf sheet—a paperlike substance that is shredded and remixed with higher-grade tobacco, the proportions varying with the quality of the brand. Xu Bing hoped to use this material as pages for a book, but it proved difficult to obtain. He finally received several bags of small squares but in the end found them unsuitable for his purpose.

The lessons Xu Bing learned about present-day tobacco production from farmers and factory employees were supplemented by visits to archives and historical buildings. One such visit took place some three hours southwest of Richmond at the Prizery in South Boston—a former factory and warehouse thought to have belonged to R. J. Reynolds Company,[10] where tobacco was "prized," or pressed layer by layer into hogshead barrels for shipping (figure 1.6). There Xu Bing first heard the recorded chanting of celebrated tobacco auctioneer Bob Cage, whom he was to meet later at his nearby studio and sculpture farm (figure 1.7).[11] Back in Richmond, visits to the Valentine Richmond History Center and the Library of Virginia provided extensive visual and textual source material that made its way into refabrications of Xu Bing's earlier pieces and inspired entirely new works (figure 1.8).

Making Tobacco Works in Virginia

Xu Bing's fourth visit to Virginia, in February 2011, consisted of a two-week residency in Richmond, during which he was accompanied by members of his studio. The residency was organized as a collaboration with Virginia Commonwealth University's highly regarded School of the Arts, which provided work space, access to equipment, and help in finding

Figure 1.7
Bob Cage winning the 1984 World Championship
Tobacco Auctioneering contest in Danville, Virginia

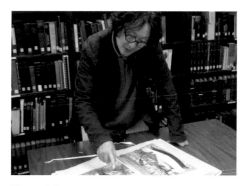

Figure 1.8
Xu Bing researching at Valentine Richmond History Center

assistants—eight former art students with a wide range of skills. The purpose of the residency was to create an entirely new body of work in response to Xu Bing's visits to Virginia and to refabricate some of the major works from Duke and Shanghai that were too fragile to transport or no longer existed. The Duke *Tobacco Book*, for instance, was destroyed by tobacco beetles deliberately inserted in the display (figure 2.5), and the remains were burned in one of Duke's celebratory bonfires.

The refabricated pieces generally involved an "updating" that added a new feature related to Virginia. The first *Tobacco Book* had included passages about the Dukes' tobacco dealings, taken from Sherman Cochran's *Big Business in China*.[12] For the Shanghai version, Xu Bing used a passage from the Chinese translation of Cochran's book. The Virginia version is rubber-stamped with text from a historical account of the first years of Jamestown in the early seventeenth century, *A True Discourse on the Present State of Virginia*, by Ralph Hamor (cat. no. 3; figure 1.9).[13] According to his studio director, Xu Bing "liked the fact that it tied together the important contribution of Rolfe to the survival of the early American experiment and the development of tobacco as a Virginia brand; the value of tobacco as a commodity, which is compared in the text to silk and silkworms (something Xu Bing has used in his work); and the fact that it mentions the cross-cultural encounter with Pocahontas and the development of a new and unique tobacco strain."[14] Made entirely of whole leaves that have been flattened and glued, *Tobacco Book* possesses the gravitas and authority of an antique tome, underscored by its four-and-a-half-foot spread and the aged appearance of its material, which evokes vellum and full-grain leather.[15]

Figure 1.9 Sayaka Suzuki (left) and Jillian Dy (right) printing *Tobacco Book*, Richmond, February 2011

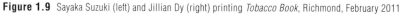
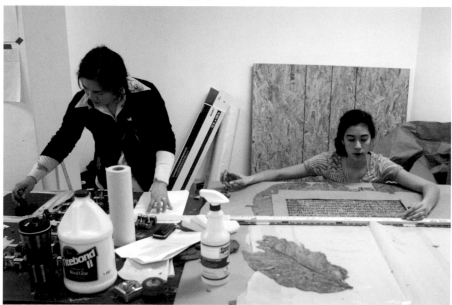

Traveling Down the River, another major refabricated work, consists of an extraordinarily long cigarette that burns across the face of a scroll painting (cat. no. 2). The scroll reproduces Zhang Zeduan's twelfth-century landscape painting *Along the River during the Qingming Festival*. At Duke the scroll was partially unrolled to approximately seventeen feet, and an equally long cigarette was obtained from the North Carolina–based Liggett Group. In the Shanghai presentation, the same scroll was unrolled to its entire length of approximately twenty-six feet to complete the burning process; the cigarette came from a factory in Yunnan province, China's premier tobacco growing region.[16] For the Virginia version, a new scroll, nearly forty-two feet long, will be used fully unrolled. In the intervening years, the cigarette has become very difficult to obtain. An extralong tobacco tube does still exist as part of the manufacturing process before being cut into normal-size pieces. But the increasing speed and complexity of automation have made it nearly impossible to extract a longer section from the machinery. Moreover, in the past several years, all states have enacted laws requiring cigarettes to meet certain fire standards by self-extinguishing when not being actively smoked. Thus the long cigarette, even if obtained, would go out rather than burn continually along the length of the scroll. Shortly before going to press with this publication, the search for the forty-foot cigarette was resolved. Two companies in North Carolina cooperated to produce a so-called misfeed, achieved by allowing an uncut tobacco tube to pass through the machinery.[17]

In their essays for this book, Wu Hung and Lydia H. Liu aptly describe the burning of the cigarette across the landscape scroll as a way of marking time. This richly metaphoric piece also presents a complex relationship to Chinese culture. The painting that Xu Bing used as the ground is one of the most famous works of Chinese art, dubbed by a prominent Western scholar as "China's Mona Lisa."[18] Xu Bing's piece defaces a national treasure, allowing a lowly habit to leave a permanent scar, like a negligent burn on an antique desk. At the same time, his provocative gesture awakens a work embalmed by its canonization. It is similar to Marcel Duchamp's Dadaist gesture of drawing a mustache on a print of Leonardo's famous lady, charting the paradoxical course of both homage and transgression that characterizes much of Xu Bing's work.

A third re-created piece also presents a rich web of metaphor and allusion. *1st Class* is the highlight of the Virginia exhibition—a massive work sitting directly on the floor in the shape and pattern of a tiger-skin rug and measuring some forty feet long by fifteen feet wide. When first made in Shanghai, the work was called *Honor and Splendor* and was formed with 660,000 "Wealth" cigarettes, at the time one of the cheapest brands in China (cat. no. 1).[19] The Virginia piece will be made with 500,000 "1st Class" cigarettes, a discount American brand. During his time in Richmond, Xu Bing created a template for the piece so that fabrication could continue after he left. His process involved researching tiger-rug patterns on the internet (figure 1.10) and using one as a guide for a full-scale drawing on brown paper (figure 1.11). A small gridded version was then made to serve as a guide (figure 1.12). The next phase involved cutting the full-scale drawing into forty-two-inch squares, which were then further cut to isolate the stripes; the paper stripes were then pinned to forty-two-inch squares of carpet. These served as guides to trace the pattern directly onto

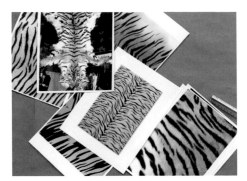

Figure 1.10
Working source images for *1st Class*

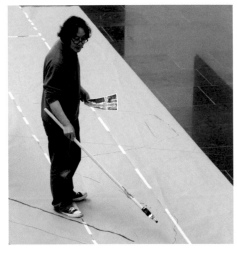

Figure 1.11 Xu Bing drawing full-scale template for *1st Class*

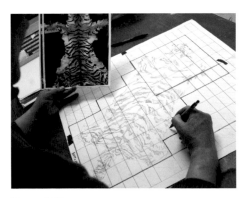

Figure 1.12
Xu Bing adjusting gridded scale-drawing of *1st Class* template prepared by Jillian Dy, Michael Muelhaupt, and Xu Bing

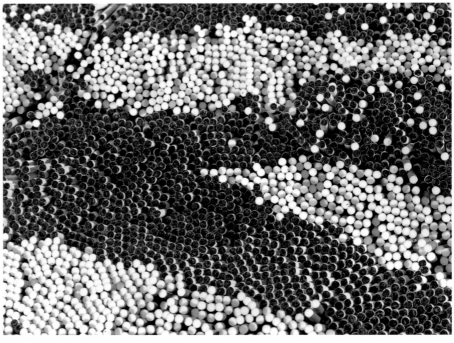

Figure 1.13 Detail of *1st Class* seen from "opposite" side

the carpet, to which the cigarettes were finally glued with industrial adhesive. Standing at a slight angle, the cigarettes create orange and white stripes depending on which end is visible—the filter end (covered with orange paper) or the tobacco end (covered with white paper) (see cover of this book). Unexpectedly, the stripes become brown and white when the cigarettes are viewed from the opposite angle, as one then principally sees the tips of tobacco and filter cellulose (figure 1.13).

The tiger-skin rug is a potent symbol of human prowess: it confirms our superiority by transforming one of nature's fiercest beasts into a lifeless skin beneath our feet. Long a royal and aristocratic sport across South, Central, and East Asia, tiger hunting was also favored by Western colonizers, whose increased levels of firepower caused far greater losses to their prey. The tiger has also fallen victim to loss of habitat, official eradication campaigns, and poaching—still a practice in many places, including China, where it is fueled by the belief that tiger parts have medicinal and aphrodisiacal properties. Xu Bing's piece trades on these associations with luxury, status, and domination. The beauty of the tiger-skin pattern, its allusions to the dangerous thrill of the hunt, and the uncanny allure of the massive display of cigarettes simultaneously glamorize and emphasize the addictive pull and risks of smoking.

For *Reel Book*, Xu Bing also updated a refabricated piece (cat. no. 15). Made for Duke and also shown in Shanghai, *Reel Book* consists of thousands of yards of one-and-one-sixteenth-inch-wide uncut cigarette paper wound around a spool, mounted on a handmade wooden reel, and threaded to a wooden crank. The book is a humorous take on a handscroll—an important

Figure 1.14
Sketch showing live flowering tobacco plant (top)
Graphite on paper, 11 x 8 ½ in. (27.9 x 21.6 cm)

format of Chinese painting in which an image is painted on a continuous length of paper or silk that remains rolled up when not being viewed. For Virginia, Xu Bing removed the prior roll with text from Robert F. Durden's *The Dukes of Durham* and replaced it with poems about the pleasures of smoking from *With the Poets in Smokeland*, a publication issued by the Richmond-based tobacco company Allen & Ginter around 1890 as a premium—an album purchased with seventy-five to one hundred cigarette-pack coupons. In addition, he had the side of the new paper roll rubber-stamped with the title of the poems.

Match Flower, made first in Shanghai (cat. no. 6), was also remade for Virginia. The piece involves an arrangement of dried branches with every tip coated in red match-head material. It appears as both a delicate flowering bush and a potent image of combustibility. Xu Bing plans to pair *Match Flower* with an entirely new work, *Nature's Contribution*, which will consist of live tobacco plants (cat. no. 7). The supple, moist, and verdant qualities of the live plants will offer a stark contrast to the brittle, desiccated, and artificial qualities of *Match Flower*. Sketches made at Duke (figure 1.14) show Xu Bing's early interest in displaying live tobacco, inspired by visits to North Carolina farms. And he had already used live plants for exhibitions in 1998 and 1999, when he displayed a huge bouquet of blooming mulberry branches in an oversize vase with hundreds of silkworms feasting on the fresh leaves (figures 2.6–2.7).[20] As of this writing, research is underway to determine how live plants can be cycled into the exhibition once they reach maturity, when, hopefully, they will be in full flower, finally realizing Xu Bing's desire for *Tobacco Project* to incorporate the full cycle of tobacco from beginning to end.

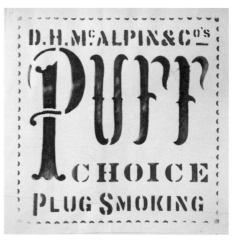

Figure 1.15
Source material for *Puff Choice*, from Valentine Richmond History Center

New Works

Several other entirely new works also draw inspiration from Xu Bing's field trips, archival research, and further reading on tobacco history in Virginia and the Americas. *Puff Choice* (cat. no. 8) resembles *Chinese Spirit* (cat. no. 17), but it extends its historical connections and graphic sensibility beyond those of a mere refabrication. It consists of a small box made of balsa wood holding cigarettes joined to a common double-length filter, which is their actual state during one type of manufacturing before the filter is cut in half to make two cigarettes. The original idea for the box came from "flat 50s," the old way of selling cigarettes in wooden boxes holding fifty smokes. Xu Bing saw these in Durham, where he also obtained double cigarettes from a nearby plant owned by the Santa Fe Natural Tobacco Company. Eleven years later, the doubles have proved difficult to find. Apparently no longer part of the U.S. manufacturing process, they are being sought in China, with a backup plan of making them by hand. The boxes are lined with laminated foil, and each lid is stamped with the work's title, *Puff Choice*—a historical tobacco brand Xu Bing encountered at the Valentine Richmond History Center (figure 1.15)—which humorously suggests the dilemma facing a purchaser of double cigarettes.

Figure 1.16
Block of compressed tobacco in original cardboard container

Inside each box is a set of printed trade cards (cat. nos. 9–13). Later also called "trading cards," these were a common feature of cigarette marketing up until World War II, when

they were largely discontinued to save paper. The first cards were made in Virginia in the mid-1870s by Allen & Ginter. Sets featuring baseball players, Indian chiefs, and female beauties encouraged brand loyalty while also stiffening the cigarette packs. The idea quickly spread, and manufacturers drew from a wide range of popular subjects based on sports, the military, and views of nature and cities. (The famous Honus Wagner baseball card is one such collectible, auctioned in 2007 for 2.8 million dollars due to its scarcity. Wagner had it removed from production as he didn't care to be associated with tobacco.)

Xu Bing made three cards for *Chinese Spirit* (cat. nos. 19–21) by redesigning historical images—substituting the faces of Al Gore and George W. Bush for Ulysses Grant and Horatio Seymour (cat. nos. 39–40), making a matchbook design with a sly message about Communism, and riffing on a Chinese cigarette ad. For *Puff Choice*, he chose five advertising images from the archives at the Valentine—based on their humorous imagery, elaborate design, and insight into nineteenth-century U.S. culture—and had them printed unaltered, except in size, using high-resolution scans and inkjet printing.[21]

At the Valentine, Xu Bing also came across a tobacco slogan that proclaimed its product to be "Light as Smoke." Already interested in the ironic contrast between the hegemonic nature of tobacco companies and the ephemeral substance they produce, he envisioned a work highlighting this duality. The resulting piece takes as its starting point a several-hundred-pound block of cured and loosely torn tobacco leaves (cat. no. 4). The block is exactly as shipped to cigarette-manufacturing plants (figure 1.16), where the tobacco would be shredded and mixed with additives and flavorings before being made into cigarettes. Xu Bing embossed the tobacco slogan onto the top of the block, contrasting the allusive phrase with the compressed tobacco's dense materiality. Xu Bing had in mind small blocks of *pu-erh* tea, a variety produced in Yunnan province of China, for which leaves are dried, rolled, and formed into balls or bricks, then aged—sometimes for decades—to encourage fermentation (figure 1.17). These compressed forms are often embossed with text, for instance the characters for "Good Year and Success." Xu Bing's work has an interesting, though unintended, resonance with fellow Chinese artist Ai Weiwei's work with *pu-erh* tea, including his *Ton of Tea* (2005; figure 1.18). Both Xu Bing's and Ai Weiwei's pieces in turn nod to American minimalist sculpture, which the artists may have encountered in reproduction during China's reengagement with the West after the Cultural Revolution, or in person in New York. (Ai Weiwei moved there in 1981, Xu Bing in 1992. For a while they shared an apartment.) Xu Bing was interested, like Ai Weiwei, in the tactile and olfactory qualities of his material and in its Chinese pedigree. Although tobacco is not as venerable as tea, which dates back some four thousand years in China, it has rapidly approached tea's popularity in a tenth of the time: tobacco was not introduced in China until the late sixteenth century (when it became a capital offense to grow or distribute it), but now pervades daily life.

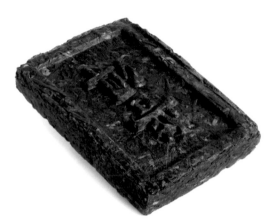

Figure 1.17
Block of *pu-erh* tea (original photograph taken upside down)

Figure 1.18
Ai Weiwei
Ton of Tea, 2005
Compressed tea and wood base
39 x 38 ¾ x 38 ½ in. (99 x 98.5 x 98 cm)
Rubell Family Collection, Miami, © Ai Weiwei

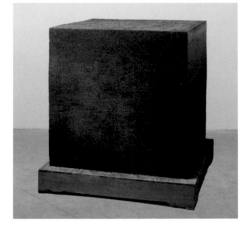

Labor and Collaboration

Xu Bing's residency and the fabrication of work in Virginia reinforced the importance of both individual and communal efforts in his creative process. *Book from the Sky* had established intensive labor as a hallmark of his work right from the start: he spent a year hand carving the four thousand character blocks from pear wood, a nearly unimaginable feat that he likened to an extended meditation (figure 1.19). His follow-up work, *Ghosts Pounding the Wall* (1990–91), involved a team of fifteen students and peasants who spent more than three weeks making ink rubbings of a section of China's Great Wall, perched upon tall bamboo scaffoldings from sunup to sundown (figure 1.20).[22] *Tobacco Project* presents several parallels. The typing of the new text for *Reel Book* took an assistant more than thirty hours on an old Smith Corona electric, carefully feeding the narrow and flimsy paper along the platen as the entire book of poems was typed three times over to form a critical mass (figure 1.21). (Xu Bing originally wanted to use a fully manual antique, but tests demonstrated that the negligible difference in appearance didn't justify the greatly increased effort.) Making the template for *1st Class* became an extended public event as Xu Bing and assistants spent days drawing, measuring, and cutting in the center of the Cochrane Atrium at the Virginia Museum of Fine Arts—the only space able to accommodate the large sheets of brown paper (figure 1.22).

The refabrication of *Match Flower* proved surprisingly complex. It involved an assistant shaving the heads off more than ten thousand kitchen matches, grinding them in a mortar and pestle, enhancing their color with the addition of red dye, and then conducting tests to determine how many dippings would be required to build up a proper match head on a twig (at least three, possibly more) and what adhesive needed to be mixed with the

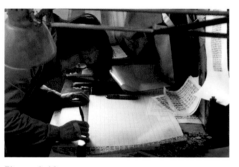

Figure 1.19
Xu Bing designing characters for *Book from the Sky*, ca. 1987

Figure 1.21
Andrea Donnelly typing text for *Reel Book*, Richmond, February 2011

Figure 1.20
Xu Bing and his crew creating *Ghosts Pounding the Wall* on scaffolding installed on the Great Wall, 1990

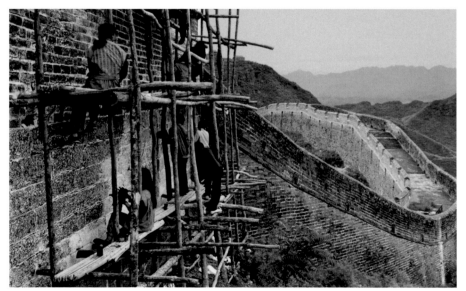

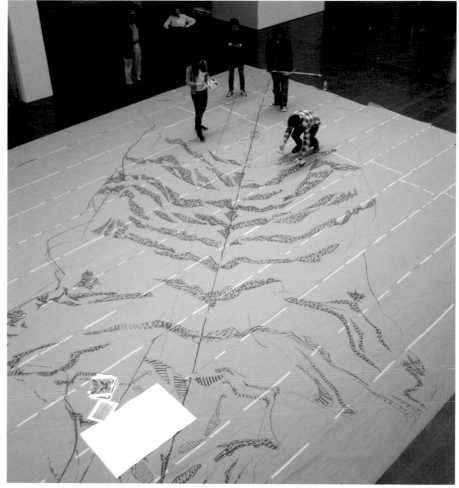

Figure 1.23
Experiments with match-head material for *Match Flower*,
February 2011

Figure 1.22 Xu Bing creating template for *1st Class* with Jillian Dy, Michael Muelhaupt, and Yi Sheng in VMFA Cochrane Atrium, February 2011

match material to bind it without visibly changing the consistency or color (figure 1.23). Next, the search was on for branches meeting Xu Bing's specifications. Trips to botanical gardens and nurseries failed to find the desired straightness, multiple forking, and correct proportion between branch and twig. Consultations with horticulturists and landscapers produced no definitive identification of the branch used in Shanghai nor an authoritative recommendation for a new type that satisfied Xu Bing. Finally, after his departure, several forages through local woods produced branches of sugar maple that seemed to be suitable. On Xu Bing's instruction, the branches were dried and subtly altered to enhance their appearance—smallest twigs removed, buds and other irregular bumps sanded down—before the hundreds of red tips were added.

A final new work raises the level of communal effort to an intellectual collaboration. From the Valentine holdings, Xu Bing selected around a hundred historical tobacco stencil

prints: brand names designed to appear on outer packaging such as boxes and crates. He planned to print versions of some of these on sheets of cigarette paper and bind them into a book of around fifty pages, with a cover made from cigarette-filter tipping paper.[23] The book was to be titled *Orinoco*, after the strain of tobacco imported by John Rolfe to Jamestown several years after his arrival in 1607. Xu Bing was particularly interested in Rolfe's naming of his tobacco:

> In 1619, he introduced what would become the most important principle in the history of tobacco—brand. He named his tobacco "Orinoco," a name that conjures in the imagination the myth of El Dorado, the lost City of Gold. . . . While for Rolfe, naming his tobacco was nothing more than naming a child, it was a small step that came to endow "tobacco" with a heretofore unknown identity.[24]

After an initial layout of the book in Richmond, it became too difficult to realize the plan of laser cutting woodblocks from the stencil designs to use for printing. With the residency finished, Xu Bing took the materials with him to Beijing and, given further time to consider, came up with a new idea to give the book greater coherence. He requested hundreds of additional scans and photocopies of stencils and invited his friend René Balcer—writer and producer for the television show *Law & Order*, among other film and television credits— to create a poem that Balcer describes as an ode to the African American women who performed the backbreaking tasks of tobacco processing. Xu Bing and Balcer had previously discussed collaborating, and this project—appropriately titled *Backbone* after one historic tobacco brand (figure 1.24)—presented a perfect opportunity (figure 1.25). As Xu Bing wrote to Balcer, it will "require sensitivity to language and a great sense of humor" to flesh out the nuances, double entendres, and other associations that would likely elude a nonnative speaker. Balcer set himself the discipline of keeping the brand names intact and not adding any other words, creating a remarkably evocative text simply by the way the brand names are arranged. The poem's first two lines, comprising five historic brands, read "OH MY BLACK SATIN DEW DROP. / OH MY BLACK SWAN QUEEN OF THE EAST." Entire lines of the free-verse poem, which incorporates a sense of blues meter, run across several pages, requiring the reader to determine where one line ends and another begins.

• • •

In *Tobacco Project*, Xu Bing has expanded his established working methods and his interest in connecting local narratives and global meanings. He uses the stories of tobacco from Duke, Shanghai, and Virginia to explore "how tobacco has driven developments in every aspect of advertising, visual communications, typography, and many other fields."[25] At the same time, he goes beyond these specific examples, treating tobacco as a universal language whose hidden codes and meanings, hypocrisies, and tangled history illuminate something larger and more profound about culture. Although there are aspects of history, sociology, and anthropology in his method, Xu Bing approaches tobacco foremost as an artist. He embraces its contradictions, admires its innovations, and appreciates its formal qualities. He also recognizes its danger. Ultimately, *Tobacco Project* exemplifies Xu Bing's subtle and finely balanced methodology as he weaves the many threads of his subject into a stunning tapestry of critique, humor, and beauty.

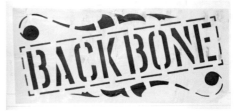

Figure 1.24
Source material for *Backbone*, from Valentine Richmond History Center

Figure 1.25
Xu Bing (far right) looking at tobacco logo designs with Carolyn Hsu-Balcer, René Balcer, and Carolyn's father Yuan Kan Hsu (from right to left)

Notes

1. Xu is his family name; Bing his given name. One's full name is commonly used in China, especially when consisting of only two characters.

2. Britta Erickson, *The Art of Xu Bing: Words without Meaning, Meaning without Words* (Washington, DC: Arthur M. Sacker Gallery, Smithsonian Institution, and Seattle and London: University of Washington Press, 2001), 21.

3. Stanley Abe, then assistant, now associate professor of art history specializing in Chinese art, first invited Xu Bing to Duke University in 1995 for three days, which included visits to the Duke Homestead and Tobacco Museum, the former Liggett and Meyers cigarette plant in downtown Durham, and farms. It was at that time that the idea for *Tobacco Project* was born. Abe and Xu Bing soon planned for a follow-up visit, organized as a residency (in 1999–2000), during which time Xu Bing visited several times, taught in two undergraduate art classes, and worked on *Tobacco Project*. Simultaneously, Abe taught a seminar focused on *Tobacco Project*.

4. See Didi Kirsten Tatlow, "China's Tobacco Industry Wields Huge Power," *New York Times*, June 10, 2010, http://www.nytimes.com/2010/06/11/world/asia/11iht-letter.html?_r=1; and Gillian Wong, "No Smoking in School: China Takes on Tobacco Battle," August 8, 2010, http://www.msnbc.msn.com/id/38593892/ns/health-addictions/ (both accessed April 25, 2011).

5. See Juncheng Qian et al., "Trends in Smoking and Quitting in China from 1993 to 2003: National Health Service Survey Data," *Bulletin of the World Health Organization*, http://www.who.int/bulletin/volumes/88/10/09-064709/en/; and Center for Disease Control, "Smoking & Tobacco Use—GATS: Fact Sheet: China: 2010," http://www.cdc.gov/tobacco/global/gats/countries/wpr/fact_sheets/china/2010/index.htm (both accessed May 2, 2011).

6. The exhibition was curated by Wu Hung. See Wu Hung, ed., *Xu Bing: Yancao jihua* [Xu Bing: Tobacco Project] (Beijing: Renmin Daxue Chubanshe, 2006).

7. This trustee is Carolyn Hsu-Balcer; see Timeline and Acknowledgments for details.

8. Xu Bing describes the nearly three years spent farming in rural Yanqing, northwest of Beijing, as a largely positive experience. Although separated from his family, he was already nineteen when the period began, wasn't sent to a remote region, and eventually was highly regarded for his calligraphy and drawing skills, producing posters, banners, and a local newspaper.

9. Xu Bing, untitled artist's statement, in *Tobacco Project: Shanghai*, exh. broch. (Shanghai: Shanghai Gallery of Art, 2004).

10. For the uncertainty of the attribution, see "History of the Prizery," http://www.prizery.com (accessed April 25, 2011).

11. Retired from the now obsolete tobacco auctioning business, Cage has turned his prodigious energies to making art, including large-scale outdoor work made from found materials that he displays at his sculpture farm in Halifax County.

12. See essays in this catalogue by Wu Hung and Lydia H. Liu for further discussion of Cochrane's book.

13. The passage was identified and recommended by Joshua Eckhardt, assistant professor of English at Virginia Commonwealth University, from *A True Discourse on the Present State of Virginia*, by Ralph Hamor (Amsterdam: Da Capo Press, 1971). The text was written by a member of the London Company who first came to Virginia about 1609 and several years later returned to London, where he published his first-hand account in 1615.

14. Jesse Robert Coffino, e-mail to author, March 3, 2011. For further discussion of Rolfe and Virginia tobacco history, see Edward D. Melillo's essay in this catalogue and Ian Gately, *Tobacco, A Cultural History of How an Exotic Plant Seduced Civilization* (New York: Grove Press, 2001).

15. Only one spread of *Tobacco Book* is printed; the rest of the book is a dummy. There are no plans to introduce live beetles into the Virginia *Tobacco Book*, or to burn it at the end.

16. It was obtained by the Shanghai Gallery of Art, and we have not been able to determine the exact source.

17. We plan to burn the cigarette once either during the installation or the opening reception, then cover the piece with a vitrine to preserve the ash.

18. Mark F. Wilson quoted in Keith Bradsher, "'China's Mona Lisa' Makes a Rare Appearance in Hong Kong," *New York Times*, July 3, 2007, http://www.nytimes.com/2007/07/03/arts/design/03pain.html (accessed April 25, 2011).

19. The cigarette brand is 富贵 (*fugui*), which translates to "wealth" or "splendor." Xu Bing and Jesse Robert Coffino chose the word "wealth" to point to the irony of the fact that they are among the cheapest cigarettes in China. The name of the work "Honor and Splendor" is from the Chinese set-phrase 荣华富贵 (*ronghua fugui*) which includes the same *fugui* in the brand name of the cigarettes. The title "honor and splendor" was chosen over "honor and wealth," because the former better conveyed the meaning of the phrase.

20. *Where Heaven and Earth Meet: Xu Bing and Cai Guo Qiang*, Bard College Center for Curatorial Studies, 1998; and *Animal, Anima, Animus*, P.S. 1, 1999.

21. One was slightly modified to convert a rectangular image into a square.

22. In *Ghosts Pounding the Wall*, Xu Bing consciously elevated the process of the work's creation, recording it through films, videos, and photographs, and even creating special uniforms printed with the characters from *Book from the Sky* to be worn by the participants. He also documented it through the preservation of his notes, sketches, and invoices for materials used. See Britta Erickson, "Process and Meaning in the Art of Xu Bing," in *Three Installations by Xu Bing*, exh. cat. (Madison: Elvehjem Museum of Art, University of Wisconsin, 1991), 19. Many of these practices have continued to greater and lesser degrees in subsequent work. The Virginia residency was heavily documented in photography and video by a team of VCU students, and an independent documentary, commissioned by Carolyn and René Balcer, is being made by New York filmmaker Joe Griffin.

23. Tipping paper, the orange cork-patterned wrapping around cigarette filters, turns out to be a difficult product to obtain, as each cigarette brand's filter-paper pattern—even though seemingly generic—is proprietary, and no company was willing to part with theirs for fear of counterfeit manufacturing. Thus, with plain, unpatterned orange tipping paper in hand, Xu Bing will undertake to create his own printed version, unless a source for the finished product can be located in China.

24. From a working draft of Xu Bing's introduction to the cigarette-paper book, when it was titled *Orinoco*. It is now titled *Backbone*.

25. Ibid.

Xu Bing's *Tobacco Project* in Virginia: A Timeline

2005

Xu Bing first considers possibility of *Tobacco Project* for the Virginia Museum of Fine Arts through his friendship with Carolyn Hsu-Balcer and René Balcer.

May 3–4, 2007

Xu Bing makes first trip to Richmond to discuss exhibition idea with VMFA staff and conduct research. Site visits in Richmond include Valentine Richmond History Center, Library of Virginia, and Philip Morris Manufacturing Center.

February 21–23, 2008

Xu Bing makes second research trip to Virginia. Site visits include Prince Edward County tobacco farms owned by Daniel Glenn Jr. (Glennview Farm) and Larry J. Allen, both in Prospect, and Edwina and Julian Covington (Sleepy Hollow Acres), near Elam. (Although the Covington farm is now defunct, it has a traditional barn, drying shed, and equipment.) Xu Bing also visits the Prizery, South Boston, Halifax County, a historic warehouse and now a center for performing arts and exhibitions, where he views a temporary exhibition *Danville and the Culture of Tobacco*. Returns to Philip Morris Manufacturing Center.

August 20–23, 2009

Xu Bing makes third research trip to Virginia. Site visits include Carl Parsons's tobacco farm in Chatham, Pittsylvania County, and the studio and sculpture farm of Bob Cage, former tobacco auctioneer, South Boston, Halifax County.

January 31–February 15, 2011 Residency

Xu Bing makes fourth trip to Richmond to create works for VMFA's exhibition during a two-week residency. His studio staff, Jesse Robert Coffino (studio director) and Yao Xin (studio assistant), join him for part of his stay.

The residency is organized as a collaboration with three departments in Virginia Commonwealth University's School of the Arts: Craft/Material Studies (Sonya Clark, Chair), Painting + Printmaking (Holly Morrison, Chair), and Sculpture + Extended Media (Amy Hauft, Chair).

Xu Bing is assisted by former VCU art students Nicole Andreoni, Amy Chan, Andrea Donnelly, Jillian Dy, Michael Muelhaupt, Yi Sheng, Sayaka Suzuki, and Jill Zevenbergen.

Among the works completed are *Tobacco Book*, typing for *Reel Book*, and template for *1st Class*.

During his stay, Xu Bing gives public talk at VCU to standing-room-only audience and meets with VMFA staff to discuss exhibition and publication. He is visited by the Balcers, as well as Richard Klein of the Aldrich Contemporary Art Museum, Ridgefield, Connecticut, where the exhibition will travel after it closes in Richmond.

For further research, Xu Bing returns to Valentine Richmond History Center and also visits John and Maggie Hager to see their tobacco memorabilia collection. John Hager is former Virginia lieutenant governor, former government affairs representative at American Tobacco Company, and current VMFA trustee.

March–August	After Xu Bing's departure, assistants continue fabrication of *1st Class*, *Light as Smoke*, *Match Flower*, *Puff Choice* boxes and trade cards, *Backbone*, and rubber stamp for *Reel Book*.
	Search for long cigarette and double cigarettes continues. Long cigarette is finally secured from East Carolina RYO, U.S. Tobacco Cooperative, and U.S. Flue-Cured Tobacco Growers; decision is made to re-create double cigarettes by hand.
	Collaboration with René Balcer on *Backbone* and printing of book in Beijing.
	Growth of live tobacco plants for *Nature's Contribution* begun by Strange's Florists, Greenhouses and Garden Centers, Richmond.
May 16	Xu Bing and John Ravenal conduct press event in New York.
Early September	Xu Bing returns for installation at VMFA.
September 10	Exhibition opens to the public. Two-day symposium is planned on Xu Bing's work with Qianshen Bai, Dan Cameron, Joseph Chang, Jim Crawford, Okwui Enwezor, Britta Erickson, Robert Hobbs, Wang Hui, Shen Kuiyi and Julia F. Andrews, Charles C. Mann, Mary Richie McGuire, John Ravenal, and Reiko Tomii.

Xu Bing giving public talk at VCU, February 2011

29

Xu Bing's *Tobacco Project* and Its Context

Wu Hung

This essay serves two interrelated purposes. The first is to place Xu Bing's art, especially his *Tobacco Project*, in the context of contemporary Chinese art. The second is to provide a basic account of the first two exhibitions of *Tobacco Project*, held in Durham, North Carolina, in 2000 and Shanghai in 2004. Rather than describing specific works in these exhibitions, this account explores the exhibition content in terms of the artist's continuous interaction with specific locations, institutions, and histories. It was through this interactive process that *Tobacco Project* gradually acquired its distinct characteristics and realized its artistic significance. This process also provides the raison d'être for the current exhibition at the Virginia Museum of Fine Arts: building on the two earlier incarnations, this third exhibition brings *Tobacco Project* back to America, but with new thematic dimensions and visual elements.

• • •

Xu Bing emerged as one of the most creative contemporary Chinese artists in the late 1980s. Before the 1980s and especially before 1976, Chinese art was subject to a persistent political campaign mobilized by ultraleftist Communist leaders. During that period, known as the Cultural Revolution (1966–76), Western-style modern art was banned. Art production was dominated by heavy-handed political symbolism, with images of Mao Zedong (1893–1976) and the revolutionary masses filling all exhibition spaces and print media. But soon after Mao died and the Cultural Revolution ended, unofficial art emerged in major cities and eventually developed into a nationwide avant-garde movement around the mid-1980s.

During this movement, known as the '85 Art New Wave, more than a hundred avant-garde art groups emerged all over the country. At the forefront of this movement was a group of young art critics and artists who took upon themselves the role of modernizing Chinese art and reconnecting it to the international art sphere. These artists embraced newly translated Western literature and philosophy, and they often made works based on reproduced Western images, which had been banned during the Cultural Revolution but became widely available in the 1980s. While this "catching up" phase inevitably involved the imitation of existing Western styles, a small number of artists stood out with their original concepts and visual language. Xu Bing was one of them. When his enormous installation *Book from the Sky* was shown at the National Art Gallery in Beijing in October 1988, it instantly set a new standard in contemporary Chinese art. In fact, at the time this work was still in development—it was not until two years later that Xu Bing would finish carving a total number of four thousand blocks of fake characters to print a hundred four-volume sets of books filled with nonsense texts.[1] In the final form, completed in 1991, copies of the unreadable books lay on the floor

The Invention of Tobacco, 2004

Forty-three neon lights forming text of early-twentieth-century Chinese tobacco advertisement, stage smoke; installation at an abandoned warehouse in Shanghai

Dimensions variable

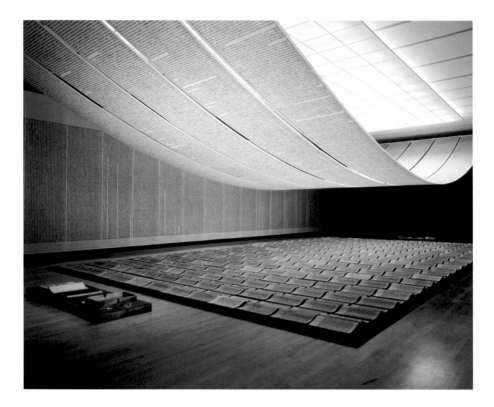

Figure 2.1
Book from the Sky, 1987–91

A hundred boxed four-volume sets of woodblock books, variable number of scrolls hanging from the ceiling, and variable number of wall panels

Installation view at National Gallery of Art, Ottawa, 1998

in rows; to one viewer, their open pages formed "a kind of metaphysical landscape, similar to a Zen garden or to a vast and unlimited plain or the sea from a bird's eye view" (figure 2.1).[2] Large paper sheets printed with the same characters covered a wall and hung from the ceiling. Whereas the vertical sheets on the wall reminded people of traditional hanging scrolls, the graceful curve of the suspended long strips evoked the movement of horizontal handscrolls. A fourth component of the installation consisted of two sets of *Book from the Sky*, placed at either end of the rows of books on low platforms composed of wood boxes. (Each of these boxes was designed to hold a set of the books.) The platforms endowed the installation with a visual focus and a feeling of solemnity, "as if [each] were an altar with relics, or a commemorative gravestone."[3]

In its representation of simultaneous deconstruction and reconstruction of traditional Chinese visual culture and aesthetics, *Book from the Sky* encapsulated the dominant tendency in Xu Bing's art before he left China for America in 1991. The technique and visual effect of *Book from the Sky* and *Ghosts Pounding the Wall*—another monumental installation from that period (figure 1.20)—were strictly traditional. Instead of sustaining Chinese cultural tradition in an unproblematic manner, however, these works were deeply iconoclastic because they "emptied" the conventional meaning of traditional forms and refashioned these forms as one man's creation. After Xu Bing moved to New York, he became more directly immersed

in contemporary art practices, and his works began to show a broader range of experimentation. Now, looking back, we can see that the 1990s was a crucial period in the history of contemporary Chinese art, during which time it became an integral component of global contemporary art and attracted growing international attention. A series of events after 1996 finally solidified the prominent status of this art in the international arena: two large survey exhibitions of contemporary Chinese art took place in the United States in 1998 and 1999;[4] Xu Bing received a MacArthur Foundation "genius" award in 1999; Wenda Gu was featured on the cover of *Art in America*; twenty Chinese artists were selected to present their work in the 1999 Venice Biennale, more than the combined number of the American and Italian participants; and Huang Yong Ping represented France in the same Biennale and made an imposing installation for the French Pavilion.

Xu Bing contributed to this trend with a string of highly original works. Whereas his interest in language and written words deepened, these works also revealed a new fascination with unconventional materials, including the use of living creatures. These two aspects found a shared focus in *Tobacco Project*. Before introducing *Tobacco Project*, however, we need to examine these two types of experimentation more closely.

Xu Bing once wrote, "In ancient Chinese the character *shu* referred to three things: books, written characters, and also the act of writing. My works are mostly concerned with this."[5] If we proceed from this statement, we can coin the term "*shu* art" for many of the works Xu Bing created during the 1990s around three different but often interconnected cores: word and character forms; the act of writing; and media technology. Important examples included *A. B. C.* (1991), *Post-Testament* (1992–93), *American Silkworm Series 1: Silkworm Books* (1994), *Square Word Calligraphy* (1994; figure 2.2), and *Tobacco Book* (2000). These "*shu* art" works usually resulted from major projects that were contemplated over a long period of time. For example, *Tobacco Book* was one of the many works Xu Bing created

Figure 2.2
An Introduction to Square Word Calligraphy (Deluxe Edition), 1994–96

Woodblock book and ink rubbing with wood cover; water-based ink on grass paper

15 3/8 x 9 x 1 in. (39 x 23 x 2.7 cm) closed

Figure 2.3

Daodejing, 2000

"American Spirit" brand cigarette package seals, typed with text from Lao Zi, *The Book of Tao,* translated by Gu Zhengku (1995)

Each strip: 23 ¼ x 1 in. (58.5 x 2.5 cm)

Typing by Kwong Li and Kristen Posehn

Figure 2.4

Re-type Book, 2000

Backing for self-adhesive labels of cigarette patent numbers, typed with excerpts from letters of J. A. Thomas (from the James Augustus Thomas Papers, 1905–41, Rare Book, Manuscript, and Special Collections Library, Duke University)

12 in. (30.5 cm) wide

Figure 2.5
A page of *Tobacco Book* (Duke version) eaten by tobacco beetles during *Tobacco Project* at Duke University, 2000

for the exhibition of *Tobacco Project* at Duke University in Durham and then re-created for both the Shanghai and Virginia venues (cat. no. 3). The book was made from cured tobacco leaves with a printed text recording the massive tobacco exports made by the Duke family business—the same family that endowed Duke University—to China in the early twentieth century. In the Duke exhibition there were also many other "books" in various forms and media, including scrolls, a slide projection, a neon light installation, a desk-top calendar, and cigarettes stamped with quotations from Mao Zedong (cat. nos. 15, 25–28; figures 2.3–2.4). Displayed at the entrance of Duke University's Perkins Library, these works simultaneously contributed to the library's holdings and challenged their institutional setting.

Among these works, *Tobacco Book* posed a special threat to the library not only because of the text printed on it (which discloses the insalubrious origin of the Duke money), but also because of a living component of the piece—tiny tobacco beetles that Xu Bing sprinkled onto the book's golden leaves (figure 2.5). Since the book was sealed inside a glass container, the beetles could not damage other books in the library's collection, but the knowledge of their existence nonetheless created anxiety. We can trace such use of living creatures to some of Xu Bing's earlier projects, such as *A Case Study of Transference* and *Cultural Animal* (1993–94), *The Parrot* (1994), *The Net* (1997), *Panda Zoo* (1998), and *American Silkworm Series 3: The Opening* (1998). Shown during the course of an exhibition at Bard College in upstate New York, for example, *The Opening* began as a vase filled with freshly cut branches of mulberry leaves on which Xu Bing placed mature silkworms (figure 2.6). The subject of the work then became the natural metamorphic process of the silkworms consuming the leaves, spinning silk, and disappearing inside cocoons. By the time the exhibition closed, all the mulberry leaves had been eaten, and only glistening silk cocoons hung on the branches (figure 2.7). This work again anticipated Xu Bing's design for *Tobacco Project*.

• • •

Figures 2.6–2.7
American Silkworm Series 3: The Opening, 1998

Live silkworms, mulberry leaves, vase

Vase: approx. 21 ⅝ in. (55 cm) high

Originally created for *Where Heaven and Earth Meet: Xu Bing and Cai Guo-Qiang,* Bard College Center for Curatorial Studies, Annandale-on-Hudson, New York, 1998

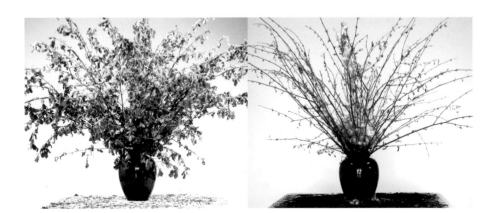

The two earlier exhibitions of *Tobacco Project* were both site-specific. The first, sponsored by Duke University, took place in November 2000 in Durham, North Carolina. The second, sponsored by the Shanghai Gallery of Art, took place across the Pacific four years later. The Shanghai exhibition inherited some objects from the previous show to indicate the connection, but it was an altogether different exhibition, enriched by some major works pertaining to the project's new location and its move from America to China.

Xu Bing once told me how he conceived *Tobacco Project*. When he visited Durham in early 2000 after Duke University had invited him to develop an art project there, his first impression of the place was the omnipresent tobacco smell in the air. A tour guide told him that Durham had been a center of the American cigarette industry since the late nineteenth century. James B. Duke (1856–1925), the founder of the American Tobacco Company in Durham, also founded Duke University. In 2000 Durham was well known not only for its cigarette factories but also for its cancer research institutes; the funds for medical research also came mainly from local cigarette manufacturers. These seemingly absurd connections between the tobacco industry and higher education and between promoting smoking and supporting medical science caught Xu Bing's attention. An additional connection soon emerged once he began to work on the project: James Duke had a deep relationship with China. It is said that upon learning of the invention of the cigarette-rolling machine in 1881, he immediately had an atlas sent to him and leafed through the maps of various countries to check their populations. Noticing a figure of 430,000,000 he exclaimed, "That is where we are going to sell cigarettes." The country was China.

Because of its location, the exhibition in Durham naturally focused on the relationship between James Duke as a tobacco tycoon and the local economy, politics, and education. This relationship constituted the primary historical context of the exhibition and underlay Xu Bing's selection of the exhibition sites, including the farmhouse where James Duke grew up; the Tobacco Museum at the Duke Homestead, which has been turned into a state historic site; the central library and alumni building of Duke University; and an abandoned cigarette factory shop in Durham. (This last site was later eliminated for safety reasons.) The second historical context of *Tobacco Project*—the expansion of the American tobacco industry in China and its consequences—was supplementary, as indicated by individual objects in the Durham exhibition. A main characteristic of this exhibition was its polycentrism: Xu Bing neither planned it as a coherent visual display nor emphasized the thematic continuity between individual works. Instead, tobacco inspired him to create a series of disparate objects and installations, each pointing to a specific memory or meditating on the general role of the cigarette in human life. Some of the objects and installations were unusually personal and intimate. For example, he projected slides of medical records belonging to his father (who died from lung cancer) onto the Pack House, a building for storing and sorting cured tobacco leaves at the Duke Homestead (figure 2.8). Others were more conceptual and metaphorical. One installation in this second category had an extremely long cigarette

Figure 2.8
Fact, 2000

Projection of artist's father's medical records on exterior wall of Pack House at Duke Homestead

burning slowly on a copy of the famous Song painting *Along the River during the Qingming Festival* (figures 2.9–2.10). The charred scar left on the painting's surface not only alludes to the damage caused by smoking but also registers the passage of time—a shared element in both smoking a cigarette and viewing a traditional handscroll.

The Shanghai exhibition retained this emphasis on chance memories and associations, but the change in location brought out the hidden potential of the project. In fact, because of the *Tobacco Project*'s relocation to Shanghai, its central concepts subtly shifted to the Sino-American relationship and China's globalization process. In this way, the movement of the project from Durham to Shanghai came to mirror the global expansion of the American tobacco industry in general and its rapid development in China specifically. Checking historical records,[6] we find that after its establishment in 1902 as a joint venture between the United Kingdom's Imperial Tobacco Company and the American Tobacco Company, the British American Tobacco Company under Duke's control made a great effort to exploit the Chinese market. The secret of its success in China lay in integrating local production and distribution into a single system. During this process, Duke transferred capital and introduced new technology as well as administrative methods to China, making China not only an immense base for tobacco and cigarette production but also a hugely profitable cigarette market. In a mere ten years, from 1905 to 1915, the British American Tobacco Company's investments in China increased more than sixfold, and its sales skyrocketed from 1.25 billion cigarettes in 1902 to 80 billion cigarettes in 1928. From 1915 through the 1920s, the United States sold more cigarettes per year (with one exception) in China than to the rest of the world combined.

Figure 2.9 (bottom right)
Traveling Down the River (Duke version), 2000

Long uncut cigarette, burned on a reproduction of *Along the River during the Qingming Festival* by Zhang Zeduan (1085–1145); video loop (produced by Tom Whiteside) showing the cigarette burning on the painting

Approx. 209 in. (530 cm) long

Installation view at Duke Homestead and Tobacco Museum, Durham, North Carolina

Figure 2.10 Burned detail of *Traveling Down the River* (Duke version)

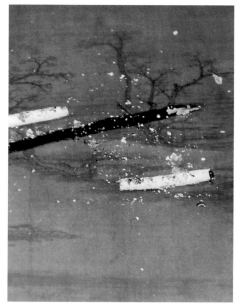

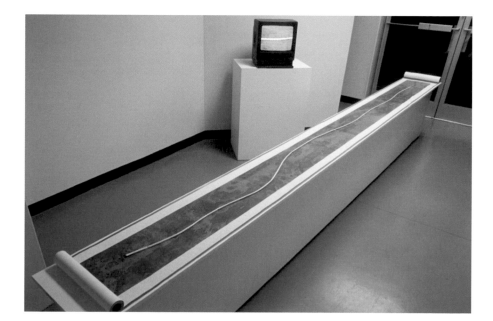

Figure 2.11 No. 3 on the Bund, location of Shanghai Gallery of Art

Figure 2.12 Installation view with *Match Flower* at Shanghai Gallery of Art, 2004

Shanghai was the headquarters of the company. Its office building at the corner of Suzhou Road and Museum Road and its factories at Lujiazui in Pudong were a model for any foreign manufacturer's successful operation in China. The startling commercial success of the British American Tobacco Company owed much to a huge and creative advertising campaign, which in turn helped reshape Shanghai's local visual culture. Advertisements of the company's products appeared in newspapers, posters, murals, scroll paintings, pamphlets, and calendars, while horse-drawn carriages and rickshaws carried the company's trademarks through Shanghai's streets. The company carefully designed its products to appeal to local tastes and cultivated loyal customers by encouraging them to collect the cigarette cards found in every pack. Each year the company put out a richly illustrated calendar, which became so popular that its publication at the end of every year was always celebrated, and supposedly it could be found everywhere in the country. The company even set up an art program to train artists and designers. It is no exaggeration to say that the British American Tobacco Company greatly contributed to the emergence and development of a new, commercial visual culture in twentieth-century China.

Xu Bing is not a sociologist or an economic historian, and his works in the Shanghai exhibition did not directly represent or analyze specific historical events. As in the exhibition at Durham, the audience found site-specific installations and a series of objects and images inspired by tobacco and tobacco products. The exhibition took place at two venues in Shanghai.[7] The main venue was the ultrafashionable Shanghai Gallery of Art in a sumptuous colonial

Figure 2.13 *Tobacco Book* (Shanghai version) on view at Shanghai Gallery of Art, 2004

building known as "No. 3 on the Bund" (Waitan Sanhao) (figures 2.11–2.12); the other location was an old, dark cigarette warehouse. Whereas the work in the warehouse, which transformed an old cigarette ad into an elusive neon light installation (see page 30), formed an independent section, four other sections together constituted the main exhibition in the Shanghai Gallery. The first of these was a prelude centered on a new version of *Tobacco Book* with the text translated into Chinese to respond to the change in the project's cultural and linguistic environment (figures 2.13, 3.3). The second section occupied the main exhibition hall with a single work: an enormous installation made of 660,000 cigarettes (cat. no. 1). Titled *Honor and Splendor* and shaped like a giant tiger-skin rug, it alluded to the cigarette's paradoxical association with seduction and danger. The third section included a collection of small-scale objects and installations inspired by tobacco and the cigarette, staged in a semi-enclosed space that resembled a smoking room in a colonial mansion (cat. nos. 31–32; figure 2.14). The fourth section comprised two installations, *Traveling Down the River* and *A Window Facing Pudong* (cat. no. 2).

Within this general structure, some images, objects, and installations evoked memories of the past; others interacted with the present—such as Pudong's fantastic cityscape outside the gallery's floor-to-ceiling windows (figure 3.4). These images mixed and overlapped, generating intricate associations in people's historical perception, as if past and present were being staged simultaneously by means of the cigarette. Viewing the show, no one could fail to hear a loud echo between the past and the present: once again there was

the huge investment of foreign money, technology, and management, and once again China provided the world with cheap labor as well as an oversized market. The meaning and historical complexity of such echoing, however, was not self-evident and had to be discovered by viewers themselves.

• • •

With multiple exhibitions at different locations and associated with different cultural environments, *Tobacco Project* has become a dynamic process of cultural and artistic inter-action, not a static display of rarefied works and images. Framed within this conceptual framework, the two earlier exhibitions in Durham and Shanghai urged the audience to reflect upon the forces of globalization and their impact on local history, bringing different places into an interactive world network. The exhibition at the Virginia Museum of Fine Arts continues in this spirit to engage art with commercial culture and international relations, but it also enriches *Tobacco Project* in terms of Xu Bing's creative interactions with a new place and audience.

Wu Hung is Harrie A. Vandersappen Distinguished Service Professor in Chinese Art History, Director of the Center for the Art of East Asia, and Consulting Curator of the Smart Museum of Art at the University of Chicago.

Figure 2.14
Rounding Up/Rounding Down, 2004
Ink on two packages of "555" brand cigarettes
2 ⅛ x 3 ½ x 1 in. (5.5 x 9 x 2.5 cm) each

Notes

1. Xu Bing also created twenty additional sets as artist's proofs.

2. Pablo J. Rico, "Xu Bing and the 'Well of Truth,'" in *Xu Bing: El Poso de la Verdad/The Well of Truth,* exh. cat. (Valencia: Sala la Gallera, 2004), 268.

3. Ibid.

4. These are *Inside Out: New Chinese Art* at the Asia Society Museum and P.S.1 Contemporary Art Center, New York; and *Transience: Experimental Chinese Art at the End of the 20th Century* at the Smart Museum of Art, Chicago.

5. Xu Bing, "To Frighten Heaven and Earth and Make the Spirits Cry," in *The Library of Babel*, exh. cat. (Tokyo: ICC-Intercommunication Center, 1998), 72.

6. Most of these records are discussed in Sherman Cochran, *Big Business in China: Sino-Foreign Rivalry in the Cigarette Industry, 1890–1930* (Cambridge: Harvard University Press, 1980). Additional information was found in the Duke University Library, the Shanghai Tobacco Museum, and other places.

7. For a detailed description and discussion of the thematic and spatial structure of the exhibition as well as the works on view, see Wu Hung, "From Durham to Shanghai: Xu Bing's *Tobacco Project*," in *Wu Hung on Contemporary Chinese Artists* (Hong Kong: Timezone 8, 2009), 163–72. The essay is translated from Wu Hong [Wu Hung], ed., *Xu Bing: Yancao jihua* [Xu Bing: Tobacco Project] (Beijing: Renmin Daxue Chubanshe, 2006).

Fragrant Mourning:
Thoughts on Xu Bing's *Tobacco Project*

Lydia H. Liu

Figures 3.1–3.2
Prophecy, 2004

Two out of five reproductions of documents from the James Augustus Thomas Papers, 1905–41, Rare Book, Manuscript, and Special Collections Library, Duke University

Each sheet: 13 ¾ x 8 ½ in. (35 x 21.5 cm)

3.1: Reproduction of British American (China) Tobacco Securities Company, Ltd., stock certificate and correspondence between BAT and Chinese distributor (Box 3)

3.2: Reproduction of ledger detailing British American Tobacco Company's China profits for 1917–19 (Box 3), with artist's pencil notations in Chinese

Installation view of *Honor and Splendor* at Shanghai Gallery of Art, 2004 (cat. no. 1)

On walking into the Shanghai exhibition space of Xu Bing's *Tobacco Project*, my first impression is not visual. A faint aroma suffuses the hallways of the Shanghai Gallery of Art, which I immediately recognize as being unique to tobacco. It is at once familiar and strange: strange because one's initial encounter with a work of contemporary art is rarely through the smell of its material. Yet perhaps we are not sufficiently aware of all the hidden forces that guide our preferences for this or that work of art. Architectural spaces and objects always release an admixture of scents, which can sneak their way into our feelings and become associated with deeply embedded memories. Could some of these elusive scents affect our ability to judge art?

Xu Bing may not be the first artist to use smell in his work, but he is someone who is capable of melding the visual, the olfactory, a certain obsession with history, and other intangibles into a single unforgettable experience. *Tobacco Project* was originally conceived and exhibited in Durham, North Carolina, where tobacco magnate James Duke (1856–1925) built his fortune and created a trust fund for Duke University (formerly Trinity College). Among Xu Bing's works are a group of archival materials related to Durham and the British American Tobacco Company, part of the Duke family's industrial empire.

One of these works, displayed inside a vitrine, is a set of Duke's annual balance sheets of income and payments, broken down in arresting detail (figures 3.1–3.2). These documents, when placed next to tobacco leaves, cigarette cases, and a pipe, have a powerful effect on

the viewer. Apart from the visual impact, one senses an invisible, ethereal tobacco spirit—perhaps the ghost of James Duke—haunting the exhibition space. This presence seems to flit between the boundaries of being and nonbeing, insinuating itself through the faint odor—a nonvisual but very physical conduit—that fills the air.

Tobacco in the air carries personal associations for me. In the late 1990s, I lived for a year near Durham, writing and doing research at the National Humanities Center. The smell of tobacco would waft by each time I drove through the city. Although Durham's old tobacco factories and warehouses were no longer functioning, the air carried the persistent smell of this dying breath. Many years later as I entered the Shanghai exhibition space of *Tobacco Project* on August 22, 2004, I found myself breathing the air of Durham again and reliving memories of people and things from that year. A local man in his seventies, for example, once said to me with a sense of pride that missionaries and the tobacco business were Durham's two chief contributions to China. I had done some research on Protestant missionaries in China, but I was entirely ignorant of the tobacco business before coming to North Carolina.

The old gentleman's pride in Durham's local history aroused my curiosity, so I gave myself a crash course and researched the history of the expansion of the American tobacco industry. One of the works I remember reading was Sherman Cochran's 1980 book *Big Business in China: Sino-Foreign Rivalry in the Cigarette Industry, 1890–1930*. The "big business" refers to what we today call the business of multinationals, and "rivalry" includes competition between colonial and domestic enterprises. Several years later, both that history and the Cochran book found their way into Xu Bing's well-crafted conception of *Tobacco Project*.

Xu Bing stands at the forefront of contemporary artists in his exploration of the history of objects and their extraordinary travels around the world. Nearly all of his works display a deep concern for history and a relentless questioning of cultural symbols. In 2000 Xu Bing was invited to be the artist in residence at Duke University, where he was drawn into the history of the Duke family. As usual, his creative response to that experience was articulated through the craft of bookmaking. A huge book made of thick tobacco leaves adorned the entrance to the Shanghai exhibition space. Nicely bound and measuring four feet high and three feet across, this book is aptly named *Tobacco Book* ("Goldleaf" book in Chinese, referring to "bright leaf" tobacco, also known as "Virginia" tobacco), a title that not only refers to the book's pages but also suggests the exchange value of their material (figure 3.3). The pages of *Tobacco Book* lay open in Shanghai, and on reading their bold type more closely, I discovered a text from the Chinese version of Cochran's *Big Business in China*, the same book that had years ago helped me understand the rise of the Duke family. Unlike the historian, the artist substitutes tobacco leaf for paper and allows the material to carry the content of the text in a self-referential manner. *Tobacco Book* is to be viewed, smelled, touched, pondered, and even chewed (I was told that at Duke, countless invisible cigarette beetles hidden in the book were soundlessly gnawing away at its leaves).

增长，但到了20世纪初期却飞速上升。从1902
年的12.5亿枝卷烟到1912年的97.5亿枝和1916年的
120亿枝，1916年的销售量为1902年的10倍。到了
1915年（此后在1910年代和1920年代的每一年里，
只有一年例外），美国每年销往中国的香烟比销往世
界其他国家香烟的总数还多。早在1916年，中国人
消费的香烟至少达到了美国大香烟消费量的五分之
四（1916年美国人吸食了157.5亿枝香烟）。

　　作为这个日益兴旺的市场上首屈一指的公司，
杜克的英美烟公司1916年在中国的销售额高达2075
万美元，获纯利润375万美元。如此之高的销售额
和如此可观的利润使杜克感到欣慰，"我们在中国取
得了很大成功，"德当时对批界说道，"对家里的潜力
无论如何估计都不会过高。

　　如果其他美国商人在1890–1915年间打入"神话
般的"中国市场的努力失败了，那么为什么杜克的
公司能成功地开拓一个真正的市场，并获得令其美
国经理者非常满意的利润？本书拟从下列与美国在
华烟草贸易有关的三个方面来探讨中国问题：杜克
美国公司的投资、公司对华籍职员的依赖以及公司
对来自东亚抵制的应对。

一个在华美国跨国公司

　　杜克公司在中国取得商业成功的部分原因，在

Figure 3.3
Tobacco Book (Shanghai version), 2004

A book made of tobacco leaves, rubber-stamped with a
passage from Sherman Cochran, *Big Business in China:
Sino-Foreign Rivalry in the Cigarette Industry, 1890–1930*
(1980), in Chinese translation

Approx. 48 x 84 ¼ in. (122 x 214 cm)

The significance of *Tobacco Project* for today's world is inseparable from the history it documents, although the tobacco leaves making up *Tobacco Book* present us with a living history rather than a dead archive. The artist's sense of reality draws the historical past and the living present together and lets them saturate each other. At the Shanghai opening of his exhibition, Xu Bing mentioned a BBC news report that the producers of the British "555" cigarette brand had plans to establish the second-largest tobacco production and supply base in China—a development going on right under our eyes. The power of Xu Bing's imagination consists in his ability to transform the exhibition space into overlapping historical narratives while at the same time offering us a visual and olfactory experience of the present.

The main gallery of the Shanghai Gallery of Art, which hosted *Tobacco Project*, is located on the Bund, overlooking the Huangpu River. Gazing out of the windows, I saw the skyscrapers of the new Pudong district on the opposite bank (cat. no. 2). On closer inspection, however, I discovered that I was actually viewing the scenery through a palimpsest: sketched out in ink across the walls and tall windows were scenes of the bygone Bund, and the new Pudong of today emerged through transparent spaces in the outline

Figure 3.4 Detail of *A Window Facing Pudong* at Shanghai Gallery of Art, 2004

(figure 3.4). Visitors were instinctively drawn to the windows, pacing in front of them and marveling at the time warp created by superimposing images of the past onto the reality of the present. After viewing the Pudong scenery through the windows and on the windows, one turned around to find a long pedestal with an installation work placed on top.

This work, also in the Virginia installation, captures a mood of melancholy (cat. no. 2; figure 2.9). On top of the pedestal is a replica of the classic Chinese landscape painting *Along the River during the Qingming Festival*, famous for its detailed and realistic portrayal of everyday life in the capital of the Song dynasty in the twelfth century. As a long uncut cigarette slowly burns, it leaves a serpentine trace of ash across the landscape. Observing this silent process, Chinese critic Li Tuo remarked that a long cigarette burning its way through the landscape will take its own time and space, meaning perhaps that the doubling of time and space—the ancient and contemporary, Chinese and foreign—is symbolically captured by the soundless, painful movement of the ash across the surface of the painting.

The first exhibition of *Tobacco Project* at Durham in November 2000 included a work made of medical records belonging to Xu Bing's late father, who died of lung cancer. The artist used a slide projector to display them on the walls of the Pack House at the Duke Homestead (figure 2.8). Although this work was not included in the Shanghai exhibition, the medical records relating to his father's cancer formed part of the exhibition there to convey Xu Bing's personal understanding of death (cat. no. 33). Drawing on a large amount of archival material and private records, Xu Bing turns his exhibition into a memorial to his father and to the other victims of tobacco consumption.

Is the memorial not long overdue? The aroma suffusing the galleries, the cigarette quietly burning across the surface of *Along the River during the Qingming Festival*, and the gigantic carpet made of hundreds of thousands of cigarettes (titled *Honor and Splendor* in Shanghai) on the floor all suggest a sacrificial offering to the dead. And as you walk into the gallery and catch a whiff of tobacco, it is as if you are taking the first step into a sacred space, like that in a Buddhist temple, to offer incense and mourn the dead. And who is responsible for the victims of tobacco consumption? A few steps away from the vitrine that holds the hospital diagnostic charts, we find the profit records of the British American Tobacco Company, stock certificates, balance of payment accounts, and columns of numbers that point to the global circulation of capital, which defines a space of desire. And what desire? Whose desire?

When the cigarette-rolling machine was first invented in 1881, James Duke's words were "Bring me the atlas!" His interest in the atlas was not in the maps but in the legends underneath them. When he saw below the map of China the magical number, "Pop.: 430,000,000," Duke exclaimed, "That is where we are going to sell cigarettes."[1] In the year 1916 alone, by Cochran's account, Duke's company enjoyed sales valued at $20.75 million with a net profit of $3.75 million in China, and one could imagine how many of the population became sacrificial objects on the altar of his capitalist machine between 1902 and 1948 when the company was in operation there.

Known for its innovative advertisements, the British American Tobacco Company invented a unique set of tobacco trade cards that flooded every corner of the global marketplace. Xu Bing put great skill to work in parodying these tobacco advertisements. The tobacco trade cards he made and titled *Chinese Spirit* are emblematic of the visual culture of the nineteenth and twentieth centuries and, in particular, the culture of photography (cat. nos. 19–21). To highlight the continuity of that culture into our own time, he reproduces photos of celebrities and politicians, such as Bush and Gore, on some of his tobacco trade cards. The surprising appearance of contemporary American politicians on these cards brings today's politics into a meaningful dialogue with the story of bygone multinationals.

Through an ironic juxtaposition of illusion and reality, Xu Bing carves out a richly imaginative social space. One work that looks like a beautiful arrangement of flower bouquets from a distance is, on closer inspection, a gigantic bunch of match sticks (cat. no. 6). The process

of inviting the viewer to approach the object and then be disabused of its glamour brings the logic behind the tobacco economy to light, for the industry relies on fantasy to distract consumers from its deadly work. Moreover, as the production of tobacco spread across the globe, match factories sprang up everywhere that recruited large numbers of women and children to work under dangerous conditions to generate surplus value for capital. These laborers, too, became sacrificial objects on the altar of capitalist machine.

One cannot avoid noticing a curious pipelike object among the numerous works on display (cat. no. 24; figure 3.5). It is a kind of multipipe—one bowl connected to six stems —resembling the steering wheel of a ship or a cross between a pipe and a steering wheel. This pipe, which is not a pipe, is reminiscent of a group of oil paintings by Belgian surrealist René Magritte. As we know, Magritte painted a tobacco pipe on canvas and underneath it wrote the famous line, "This is not a pipe." His series of paintings is a semiotic game played with images and text; likewise, Xu Bing's pipe is not a pipe, but the semiotic game he plays is primarily political.

Figure 3.5
Pipe, 2004
Wood tobacco pipe with five added stems and tobacco
2 x 12 ¼ x 12 ¼ in. (5 x 31 x 31 cm)

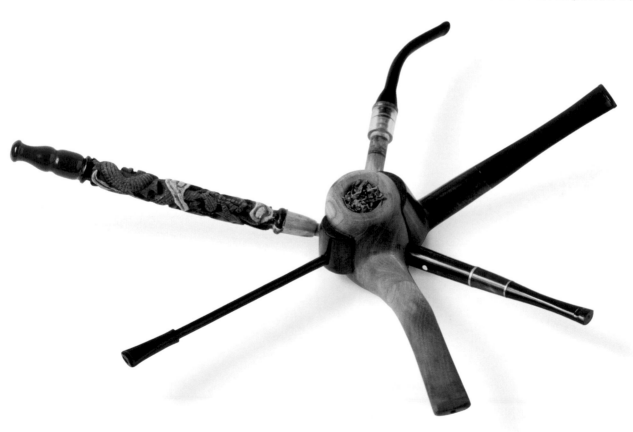

Turning away from the self-indulgences of European surrealist art, Xu Bing's nonpipe symbolizes a global network of socioeconomic exchange where monetary symbols and linguistic symbols circulate with little constraint and where everyday life is flooded with tobacco, cigarette cases, matches, and commercials. In its resemblance to a steering wheel, Xu Bing's nonpipe subtly alludes to the shipping vessels and gunboats of the great imperial powers that not only brought about war, death, and trauma but also helped to carry the British American Tobacco Company into the world market.

Lydia H. Liu is W. T. Tam Professor in the Humanities, Columbia University.

Notes

Originally published in Chinese as "Smell, Ceremony, and Xu Bing's Installation Art," in *Xu Bing: Yancao jihua* [Xu Bing: Tobacco Project], ed. Wu Hung (Beijing: Renmin Daxue Chubanshe, 2006). Translated into English by Jesse Robert Coffino and revised by the author.

1. Sherman Cochran, *Big Business in China: Sino-Foreign Rivalry in the Cigarette Industry, 1890–1930* (Cambridge: Harvard University Press, 1980), 10–11.

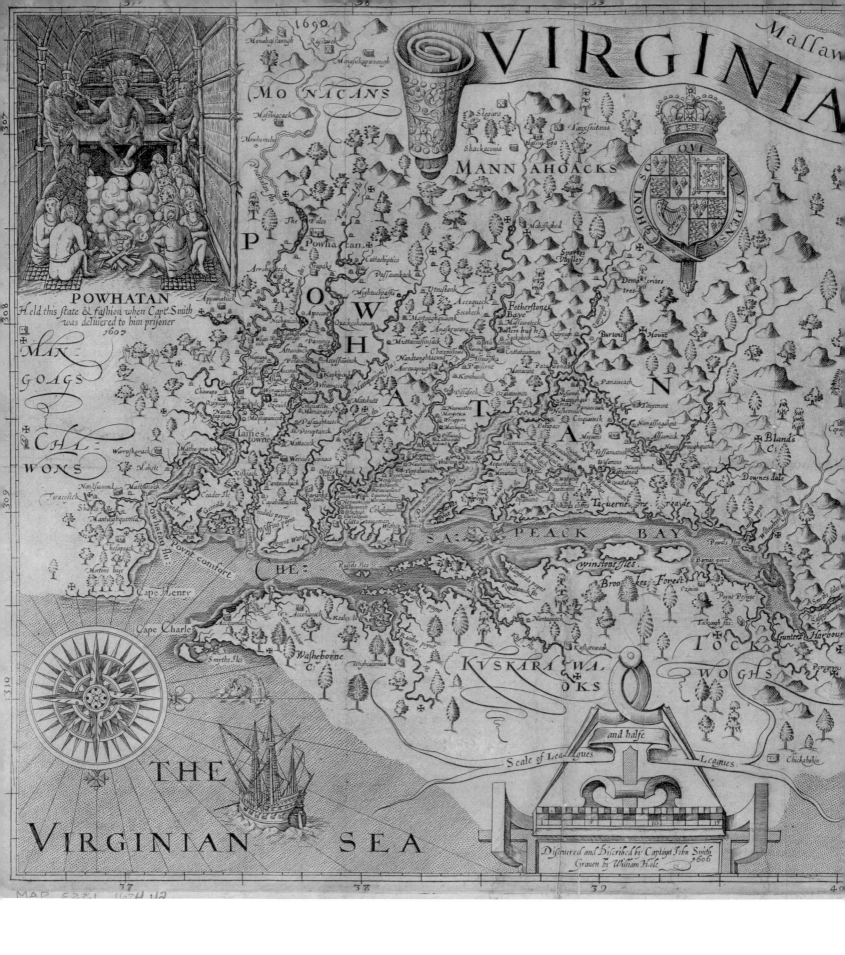

VIRGINIA

Maſſaw

1690

MONACANS

MANNAHOACKS

POWHATAN
Held this state & fashion when Capt. Smith
was deliuered to him prisoner
1607

POWHATAN

MAN-
GOAGS

CHI-
WONS

James
towne

Cape Henry

Cape Charles

CHE: SA PEACK BAY

KVSKARA WA OKS

TOCK
WOGHS

THE

VIRGINIAN SEA

Scale of Leagues

and halfe

Leagues

Discouered and Described by Captayn John Smith 1606
Grauen by William Hole

A Land "Wholly Built Upon Smoke": Colonial Virginia and the Making of the Global Tobacco Trade, 1612–1776

Edward D. Melillo

"The Floridians, when they travel, have a kind of herb dried, which with a cane and an earthen cup in the end, with fire and the dried herbs put together, do suke through the cane the smoke thereof, which smoke satisfieth their hunger, and therewith they live four or five dayes without meat or drinke."[1] So begins the first English-language account of Amerindian tobacco use. John Sparke's tale of the mysterious herb's powers, taken from his account of Sir John Hawkins's second slaving expedition to the Americas in 1565, beguiled British imaginations and helped launch the global career of *Nicotiana*, the tobacco plant.

Tobacco was just one of the many curious plant specimens collected by European explorers during their early encounters with the peoples and environments of the Americas. From Columbus's initial voyage in 1492 onwards, the influx of exotic flora from across the Atlantic Ocean altered European landscapes and cultural practices in enduring ways. Ireland before the potato, Germany before chocolate (cacao), Italy before the tomato, and Britain before tobacco seem unimaginable, yet all of these plants arrived aboard ships returning from the New World.[2]

Unlike many of its companion species from the Americas, tobacco experienced limited success on European farms. State monopolies, prominent antitobacco campaigns, and demanding labor requirements conspired with poor soil conditions, harsh climates, and land shortages to hinder expansion of cultivation. Instead, tobacco merchants depended upon production in overseas territories to supply Europe's burgeoning domestic markets.[3]

Shortly after its inception in 1607 as Britain's first North American colony, Virginia became synonymous with tobacco cultivation. The Virginia Company of London received its charter from the English crown on April 10, 1606. The following year, Captain Christopher Newport led an expedition of 105 settlers to the southern shores of the Chesapeake Bay Mooring at a swampy island on the James River, they established a fortified outpost called Jamestown. Deficient in precious metals and lacking a clear industrial foothold, the Virginia landscape offered its new residents few obvious foundations for profitable enterprise. Yet beneath their feet enterprising settlers soon discovered economic potential in the colony's fertile topsoil.

Among the first European depictions of the Chesapeake Bay is John Smith's *A Map of Virginia* (Oxford University, Joseph Barnes, 1612). Engraved by William Hole, the map is oriented with the west at the top. An image of Chief Powhatan holding a tobacco pipe while presiding over his court can be seen in the upper left corner.

In 1612, John Rolfe—best remembered for his marriage to Pocahontas, daughter of Chief Powhatan of the Pamunkey Indians—became the first Virginia colonist to plant a nonnative variety of tobacco. Instead of cultivating *Nicotiana rustica*, the harsh, nicotine-heavy species grown for centuries by North American Indians, Rolfe chose a milder West Indian variety, *Nicotiana tabacum*, which he had likely obtained in 1609 during a ten-month sojourn in Bermuda as a castaway from the shipwrecked *Sea Venture*. At Varina Farms, upstream from the Jamestown settlement, Rolfe harvested his first crop of Virginia tobacco. The pioneer planter named his leaves "Orinoco" after the river in Guiana (now Venezuela) along which Sir Walter Raleigh had journeyed in 1595 while searching for the fabled city of gold, El Dorado.[4]

Through experimentation with the "golden weed," Rolfe had stumbled upon his own El Dorado. On July 20, 1613, the cargo ship *Elizabeth* reached England with the Virginia colony's first shipment of cured leaves, densely packed into massive wooden barrels known as "hogsheads." Rolfe's botanical innovation captivated English consumers. The "sweet-scented leaf," as London merchants dubbed the superior grades of Virginia tobacco, promptly became a cash crop to rival all others. British barrister Andrew Steinmetz was hardly exaggerating when he wrote that by 1615 "the fields, the gardens, the public squares, and even the streets of Jamestown, Virginia, were planted with tobacco—nay, it became not only the staple, but the currency of the colony."[5] Indeed, tobacco offered a convenient medium of international exchange. In 1622, twelve male colonists each paid 120 pounds of tobacco for the maritime passage of a dozen women of marriageable age from England.[6]

Not everyone was pleased with the omnipresent Virginia leaves. As King Charles I grumbled, tobacco so dominated colonial life that Virginia was "wholly built upon smoke, tobacco being the only means it hath produced."[7] Yet behind this hazy façade, Virginia was fast becoming the focal point in an intricate network of global exchanges. Virginia's tobacco farmers depended upon the labor of West African slaves, the spread of European print culture, and extensive economic protections from the British crown to grow a plant that had been cultivated by peoples of the Americas for many millennia. Scottish "tobacco lords" built fortunes on the transatlantic trade in Virginia's staple crop, while American revolutionaries supplemented their war chest with funds from the consignment of tobacco to the French government. It is hardly a stretch to say that Virginia's colonial development cannot be sufficiently explained without granting a central role to the tobacco leaf.

Throughout history, divergent cultural attitudes toward tobacco have blended in unique ways with the complex chemistry of the plant itself. Like tomatoes, potatoes, and peppers, tobacco is a member of the nightshade (*Solanaceae*) family. Scientists recognize seventy naturally occurring *Nicotiana* species, of which forty-five are native to the Americas. Tobacco plants produce varying concentrations of the psychoactive alkaloid known as nicotine, a compound that acts as a stimulant in mammals and is the principal source of

Figure 4.1
This carefully executed wharf scene adorns *A Map of the Most Inhabited Parts of Virginia Containing the Whole Province of Maryland with Part of Pensilvania* [*sic*]*, New Jersey and North Carolina* by Joshua Fry and Peter Jefferson (London: Robert Sayer and Thomas Jefferys, 1775). The map cartouche, designed by Francis Hayman, shows a Virginia tobacco planter, seated on the left, attending to the shipment of his valuable product, while a slave on the right rolls a hogshead, presumably packed with cured tobacco leaves.

tobacco's addictive properties. For thousands of years, from as far south as Paraguay to as far north as the St. Lawrence River Valley, Amerindian peoples used tobacco as a healing herb, a social stimulant, a diplomatic tool, and a sacred vehicle for accessing the divine.[8]

After his arrival in Guanahaní (San Salvador, Bahamas) on October 12, 1492, Columbus noted that representatives of the local Taíno population regaled him with "some dried leaves, which must be held in high esteem here."[9] Shortly thereafter, one of Columbus's scouts, Rodrigo de Jeréz, became the first European to consume tobacco. Upon his return to Ayamonte, Spain, his fellow townspeople were appalled to find wisps of smoke emanating from the sailor's nostrils. The Holy Inquisition promptly sent Rodrigo de Jeréz to prison for his demonic behavior.[10]

53

From the sixteenth century onwards, the rapid proliferation of European print culture provided diverse audiences with further clues about tobacco use in the Americas.[11] The publication of Gonzalo Fernández de Oviedo y Valdés's *Historia general y natural de las Indias* in 1535 gave curious residents of the Old World a window into the social life surrounding this New World plant. Oviedo y Valdés, a Spanish mine supervisor who spent a decade in the Americas and took up smoking to alleviate the pains of syphilis, summarized the predictive powers that tobacco held for the Caquetio of northwestern Venezuela:

> There is in the country an herb which they call *tabaco*, which is a kind of plant, the stalk of which is as tall as the chest of a man . . . having twisted the leaves of this herb in a roll to the size of an ear of corn, they light it at one end, and they hold it in their mouth while it burns, and blow forth [smoke], and when it is half burned, they throw down what is rolled up [i.e., the cigar]. If the burned part of the tobacco stays fixed in the form of a curved sickle, it is a sign that the thing which they desire will be given; if the burned portion is straight, it is a sign that the contrary of what is desired will happen, and what they hope to be good will be bad.[12]

Despite the intrigue that such accounts generated, most Europeans spurned tobacco's sacred meanings, embracing the leaves for their more mundane physiological effects and their alluring commercial potential. Portuguese and Spanish sailors were quick to adopt the golden weed, which became their calling card at port cities in both hemispheres. Spanish mariners introduced tobacco from Acapulco to Manila in 1575, while Portuguese and Dutch traders extended the plant's botanical reach to equatorial Africa in the late sixteenth century. By 1623, English explorer Richard Jobson was hardly surprised to find residents of the Gambia River region cultivating tobacco, "which is ever growing about their houses." Jobson described how these men and women smoked the dried leaves with "fine neate Canes."[13]

At roughly the same time that West Africans were cultivating tobacco and John Rolfe was experimenting with varieties of *Nicotiana tabacum* in Virginia, Chinese farmers were sowing their first seeds of the exotic plant. During the mid-1600s, the scholar Fang Yizhi (1611–1671) recorded the arrival of tobacco in the Middle Kingdom:

> Late in the reign of Emperor Wanli [from 1573 to 1620], people brought it to Zhangzhou and Quanzhou. The Ma family processed it, calling it *danrouguo* [fleshy fruit of the *danbagu*]. It gradually spread within all our borders, so that everyone now carries a long pipe and swallows the smoke after lighting it with fire; some have become drunken addicts.[14]

Recent evidence suggests that tobacco appeared in China earlier than Fang Yizhi surmised. In 1980, an archaeological team in the southern province of Guangxi unearthed three porcelain tobacco pipes from the Ming Dynasty. Inscriptions on the artifacts situate their origins at 1550.[15]

As all accounts demonstrate, tobacco had permeated the major arteries of world trade by the early 1600s. Ironically, the global expansion of tobacco use met one of its most formidable challenges among the English royalty. In part, the Crown's hostility stemmed

from Spain's early dominance of the international tobacco trade. England and Spain were locked in a bitter rivalry at the end of the sixteenth century. In 1588, Philip II sent the Spanish Armada to England with the objective of overthrowing Queen Elizabeth I. During a series of dramatic naval engagements, Vice Admiral Sir Francis Drake and his fleet of agile warships sent a battered Armada limping back to the Iberian Peninsula.[16]

Spain had far more success in its commercial conquests. By the end of the sixteenth century, England's adversaries had established Havana and Seville as the dominant nodes in the transatlantic axis of tobacco commerce. Spaniards shipped the valuable leaves from their Caribbean plantations to the bustling Andalusian port city where the tobacco underwent processing for reexport to European markets.[17]

English national pride, along with the perception that tobacco threatened the vigor of the body politic, inspired the period's most widely circulated antitobacco treatise. In his anonymously published *A Counter-blaste to Tobacco* (1604), King James I of England derided smoking as a "vile and stinking a custome," which "brought foorth a generall sluggishnesse" among its practitioners. The monarch, torn between his distaste for the exotic plant and his craving for the customs revenue it generated, refrained from outlawing tobacco. Instead, he imposed a 4,000 percent duty on its sale, placing tobacco beyond the reach of commoners.[18] Ultimately, however, the *Counter-blaste* demonstrated the king's ignorance of the consumer

Figure 4.2
British gentlemen share the pleasures of Virginia "sweet-leaf" tobacco in "A Smoking Club," a print illustrating Frederick William Fairholt's book, *Tobacco, Its History and Associations* (London: Chapman and Hall, 1859).

A SMOKING CLUB.

Figure 4.3
This sixteenth-century Spanish depiction of West Indian tobacco circulated in Britain and appeared in an English edition of Nicolás Monardes's *Joyfull newes of the new-found worlde*, translated by John Frampton (London: E. Allde by assigne of Bonham Norton, 1596).

revolution overtaking his kingdom; by 1619, the Crown had granted Virginia a monopoly on tobacco exports to England. "That bewitching vegetable"—as William Byrd II, founder of Richmond, Virginia, described tobacco—had cast its spell.[19]

Tobacco acted as a social salve during a period of political upheaval. Thomas Hobbes, who fled to Paris during the English Civil War (1642–51) and memorably characterized life in the state of nature as "solitary, poor, nasty, brutish and short," made his own seventeenth-century existence tolerable with a daily regimen of no fewer than twenty pipes of tobacco.[20] By the end of the seventeenth century, more than half of all Englishmen smoked the golden weed; its price had fallen enough "so that every ploughman has his pipe."[21]

With each passing year, more of the tobacco chewed, snuffed, and smoked in England, Scotland, and Wales came from Virginia. A British visitor to the Commonwealth in 1690 acerbically commented, "For the most general true character of Virginia is this, that as to the natural advantages of a country, it is one of the best; but as to the improved ones, one of the worst in all the English plantations. . . . So it is at present, that Tobacco swallows up all other Things."[22] *Nicotiana tabacum* not only had emerged as the first truly global agricultural commodity, it had become the centerpiece of the world's earliest plantation monoculture, a system in which farmers cultivate one species to the exclusion of all others.[23]

Tobacco is a delicate crop, requiring meticulous care at each stage of cultivation. "The tobacco-grower has to tend his tobacco not by fields, not even by plants, but leaf by leaf. The good cultivation of good tobacco does not consist in having the plant give more leaves, but the best possible," remarked Cuban anthropologist Fernando Ortiz.[24] Removal of the leading stem and the lateral shoots of the plant—known as "topping and suckering"—diverts the plant's energy toward leaf production, thereby increasing the nicotine content of the leaves. Virginia tobacco planters often performed this delicate operation with their untrimmed thumbnails, which they would harden by repeated passes through a candle's flame.[25]

The management of soil fertility also became an essential skill of the successful tobacco farmer. *Nicotiana tabacum* has a voracious appetite for nitrogen, phosphorous, and calcium, and soil exhaustion becomes a pressing problem after only a few years of cultivation. Tidewater planters—those who farmed the eastern coastal region of Virginia below the Piedmont plateau—often rotated their crops, cultivating tobacco for three years, farming corn for the next three, and allowing their fields to revert to forests for twenty years. This approach helped worn-out lands recover from the severe nutrient demands imposed by a plant that required "uncommon fertility of soil," as gentleman farmer Thomas Jefferson put it in his *Notes on the State of Virginia*.[26]

Between 1620 and 1680, small tobacco farms dominated Virginia's coastal landscape. As wealthier planters expanded their holdings, chronic labor shortages arose. Initially, growers hired European indentured servants who paid for their transatlantic passage with

several years of fieldwork. By the end of the seventeenth century, the servant trade had turned prohibitively expensive. The emergence of an English slaving fleet allowed Virginia's nascent planter class to reconstitute their workforce with African slaves. Between 1700 and 1780, approximately 78,000 slaves arrived at the colony's ports.[27]

Curiously enough, many of the women and men who survived the hellish ordeal of the Middle Passage arrived on Virginia's shores with abundant knowledge of the tobacco plant. Slaves from Senegambia, the Gold Coast, and the Windward Coast of West Africa came from cultures that had featured tobacco as a staple crop for several generations. Extensive knowledge of tobacco farming made certain slaves more desirable at auctions, and the Virginia planters who purchased them appropriated these African cultivation strategies from their field laborers.[28]

During the transition from a nominally free workforce to a system reliant on slavery, tobacco output skyrocketed. Exports from Virginia and Maryland tripled between 1725 and 1776.[29] However, much like the transatlantic system of slavery upon which it depended, tobacco production was never free from constraints. As plummeting prices in the 1630s and 1680s had demonstrated, stability was perpetually elusive for the tobacco farmer. Also absent during this period was an accepted standard for the leaves being shipped abroad. After taking office in 1727, Virginia governor William Gooch worked tirelessly to implement a system of quality controls for the colony's staple crop. His legislative masterpiece, the Virginia Inspection Act of 1730, required that growers transport their tobacco to public warehouses where at least two assessors would crack open the hogsheads "and diligently view and examine the same" to determine "that the [tobacco] is good, sound, well-conditioned, and merchantable, and free from trash, sand, and dirt."[30] Inspectors burned any tobacco that failed to meet these criteria. Initially, these rules provoked resistance, even rioting, among planters; they also heralded a new phase in the long march toward a more uniform tobacco plant. As markets expanded and tastes developed among consumers, buyers demanded further refinements to their commodity. The resulting experiments and modifications conducted by farmers, and eventually by scientists, confirmed that the emerging capitalist marketplace was as much a botanical intervention as a commercial revolution.

Among the beneficiaries of these new benchmarks was a tight-knit group of Scottish merchants. Concentrating their capital on the transatlantic tobacco trade, this cartel transformed Glasgow into an unrivalled hub for re-exportation of the golden weed to continental Europe. By 1762, tobacco grown in the Chesapeake Bay region accounted for 85 percent of all Scottish imports from North America. Glasgow's "tobacco lords" met frequently to strategize about their profitable trade. Sporting "red cloaks, satin suits, powdered wigs, three-cornered hats, and gold-topped canes," Scotland's elite amassed their fortunes by pairing "sweet-scented" Virginia tobacco with the new cravings of European consumers.[31]

Across the Atlantic, a similar tobacco aristocracy was emerging. Although the vast majority of Virginia's farmers spent their lives mired in debt, eking out a hardscrabble existence from one growing season to the next, a few men, such as Robert "King" Carter, William Randolph, Benjamin Harrison, and Richard Lee, built sprawling tobacco estates. Their agrarian dominance translated into an unbridled political oligarchy. "As early as 1660 every seat on the ruling Council of Virginia was held by members of five interrelated families, and as late as 1775 every council member was descended from one of the 1660 councilors," notes one historian.[32]

Despite underwriting the consolidation of colonial Virginia's landed gentry, tobacco also helped North American colonists topple British colonial rule. During the American Revolution, Virginians traded tobacco for shipments of ammunition from France via the West Indies. Additionally, Benjamin Franklin secured a substantial monetary loan from the French Government using five million pounds of Virginia tobacco as collateral.[33] As one historian aptly put it, the 1700s were the years of "King Tobacco Diplomacy."[34]

In the centuries following 1776, tobacco incited more than its share of controversy. A 2009 World Health Organization report noted, "Tobacco use is the leading cause of preventable death, and is estimated to kill more than 5 million people each year worldwide."[35] Despite the overwhelming human tragedy that tobacco use has caused, if we take "a plant's eye view" of history, the tale of *Nicotiana tabacum* would be one of remarkable success.[36] Currently, 130 countries grow commercial varieties of tobacco, making it the world's most widely cultivated nonfood crop.[37] Little could Charles I have known that the Virginia Colony, "wholly built upon smoke," would play such a crucial role in the globalization of a humble weed from the Americas.

Edward D. Mellilo is Assistant Professor of History at Amherst College.

Notes

1. John Sparke, as quoted in E. R. Billings, *Tobacco: Its History, Varieties, Culture, Manufacture, and Commerce* (Hartford, CT: American, 1875), 38.

2. Alfred Crosby, *The Columbian Exchange: Biological and Cultural Consequences of 1492* (Westport, CT: Greenwood, 1972).

3. David Ormrod, *The Rise of Commercial Empires: England and the Netherlands in the Age of Mercantilism, 1650–1770* (New York: Cambridge University Press, 2003), 199–200; Stanley Gray and V. J. Wyckoff, "The International Tobacco Trade in the Seventeenth Century," *Southern Economic Journal* 7, no. 1 (1940): 1–26.

4. Philip D. Morgan, "Virginia's Other Prototype: The Caribbean," in *The Atlantic World and Virginia, 1550–1624*, ed. Peter C. Mancall (Chapel Hill: University of North Carolina Press, 2007), 362.

5. Andrew Steinmetz, *Tobacco: Its History, Cultivation, Manufacture, and Adulterations* (London: Richard Bentley, 1857), 17.

6. W. A. Penn, *The Soverane Herbe: A History of Tobacco* (New York: Dutton, 1901), 73; Eric Burns, *The Smoke of the Gods: A Social History of Tobacco* (Philadelphia: Temple University Press, 2007), 71.

7. King Charles I, as quoted in George Louis Beer, *The Origins of the British Colonial System, 1578–1660* (New York: Macmillan, 1908), 91.

8. R. S. Lewis and J. S. Nicholson, "Aspects of the Evolution of *Nicotiana tabacum* L. and the Status of the United States *Nicotiana* Germplasm Collection," *Genetic Resources and Crop Evolution* 54, no. 4 (2007): 727; Jack E. Henningfield and Mitch Zeller, "Nicotine Psychopharmacology Research Contributions to United States and Global Tobacco Regulation: A Look Back and a Look Forward," *Psychopharmacology* 184, nos. 3–4 (2006): 286–91; and Joseph C. Winter, ed., *Tobacco Use by Native North Americans: Sacred Smoke and Silent Killer* (Norman: University of Oklahoma Press, 2000), 10–11. On the cultural processes that transcend biological impulses and underlie the diverse array of human approaches to tobacco, see Jason Hughes, *Learning to Smoke: Tobacco Use in the West* (Chicago: University of Chicago Press, 2003).

9. Christopher Columbus, as quoted in Felipe Fernández-Armesto, *Columbus on Himself* (Indianapolis: Hackett, 2010), 59.

10. C. de Jesus, ed., *The Tobacco Monopoly in the Philippines: Bureaucratic Enterprise and Social Change, 1776–1880* (Manila: Ateneo de Manila University Press, 1980), 2.

11. For more on this relationship, see Peter C. Mancall, "The Tales Tobacco Told in Sixteenth-Century Europe," *Environmental History* 9, no. 4 (2004): 648–78.

12. Gonzalo Fernández de Oviedo y Valdés, as quoted in Johannes Wilbert, *Tobacco and Shamanism in South America* (New Haven: Yale University, 1987), 11.

13. Anthony Reid, "From Betel-Chewing to Tobacco-Smoking in Indonesia," *The Journal of Asian Studies* 44, no. 3 (1985): 535; Iain Gately, *Tobacco: A Cultural History of How an Exotic Plant Seduced Civilization* (New York: Grove, 2001), 59; and Richard Jobson, *Discovery of the River Gambia and the Golden Trade of the Aethiopians*, ed. Charles G. Kingsley (1623; repr., Devonshire, UK: Speight and Walpole, 1904), 159 and 119.

14. Fang Yizhi, as quoted in Timothy Brooke, "Smoking in Imperial China," in *Smoke: A Global History of Smoking*, ed. Sander L. Gilman and Xun Zhou (London: Reaktion, 2004), 84.

15. Yangwen Zheng, *The Social Life of Opium in China* (New York: Cambridge University Press, 2005), 26.

16. For an elegant account of Drake's role in the defeat of the Armada, see Harry Kelsey, *Sir Francis Drake: The Queen's Pirate* (New Haven: Yale University Press, 1998), Ch. 2.

17. Laura Nater, "Colonial Tobacco: Key Commodity of the Spanish Empire, 1500–1800," in *From Silver to Cocaine: Latin American Commodity Chains and the Building of the World Economy, 1500–2000*, ed. Steven Topik, Zephyr Frank, and Carlos Marichal (Durham: Duke University Press, 2006), 102–3.

18. James I (King of England), *A Counter-blaste to Tobacco*, ed. Edmund Goldsmid (1604; repr., Edinburgh: E. & G. Goldsmid, 1885), 7–8, 12; Todd Butler, "Power in Smoke: The Language of Tobacco and Authority in Caroline England," *Studies in Philology* 106, no. 1 (2009): 102.

19. William Byrd II, *The Westover Manuscripts* (Petersburg, VA: Printed by E. and J. C. Ruffin, 1841), 2. A politician, writer, and planter, Colonel William Byrd II (1674–1744) is widely recognized as the founder of Richmond, Virginia.

20. Thomas Hobbes, *Leviathan: Or the Matter, Forme and Power of a Commonwealth Ecclesiasticall and Civil*, ed. Michael J. Oakeshott (1651; repr., New York: Simon and Schuster, 1997), 100. D. A. Farnie, "The Commercial Empire of the Atlantic, 1607–1783," *The Economic History Review* 15, no. 2 (1962): 208.

21. Gregory King, as quoted in Nuala Zahedieh, "Economy," in *The British Atlantic World, 1500–1800*, ed. David Armitage and Michael J. Braddick (New York: Palgrave Macmillan, 2002), 55.

22. John Jones Spooner, "The Present State of Virginia," in *Collections of the Massachusetts Historical Society*, ed. The Massachusetts Historical Society (Boston: John H. Eastburn, 1835), 124, 127.

23. The other plausible contender for these distinctions is sugar. For an engrossing account of sugar's role in world history, see Sidney W. Mintz, *Sweetness and Power: The Place of Sugar in Modern History* (New York: Viking, 1985).

24. Fernando Ortiz, *Cuban Counterpoint, Tobacco and Sugar*, trans. Harriet de Onís, 4th ed. (Durham: Duke University Press, 2003), 24.

25. Lois Green Carr, Russell R. Menard, and Lorena S. Walsh, *Robert Cole's World: Agriculture and Society in Early Maryland* (Chapel Hill: University of North Carolina Press, 1991), 60–61.

26. Thomas Jefferson, *Notes on the State of Virginia*, ed. Frank Suffelton (1781; repr., New York: Penguin Books, 1999), 173. The first extensive study of this issue was Avery Odelle Craven, *Soil Exhaustion as a Factor in the Agricultural History of Virginia and Maryland, 1606–1860* (Urbana: University of Illinois, 1925). For an alternative perspective, see Carville Earle, "The Myth of the Southern Soil Miner: Macrohistory, Agricultural Innovation, and Environmental Change," in *The Ends of the Earth: Perspectives on Modern Environmental History*, ed. Donald Worster (New York: Cambridge University Press, 1988), 175–210.

27. Philip D. Morgan, *Slave Counterpoint: Black Culture in the Eighteenth-Century Chesapeake & Lowcountry* (Chapel Hill: University of North Carolina Press, 1998), 59; and Herbert S. Klein, *The Atlantic Slave Trade*, 2nd ed. (New York: Cambridge University Press, 2010), 44.

28. Lorena S. Walsh, *From Calabar to Carter's Grove: The History of a Virginia Slave Community* (Charlottesville: University Press of Virginia, 1997), 63–65; and Joseph E. Holloway, "The Origins of African-American Culture," in *Africanisms in American Culture*, ed. Joseph E. Holloway, 2nd ed. (Bloomington: Indiana University Press, 1990), 31.

29. Aubrey C. Land, "The Tobacco Staple and the Planter's Problems: Technology, Labor, and Crops," *Agricultural History* 43, no. 1 (1969): 76. For more on this transition, see Allan Kulikoff, *Tobacco and Slaves: The Development of Southern Cultures in the Chesapeake, 1680–1800* (Chapel Hill: University of North Carolina Press, 1986).

30. William Waller Hening, ed., *The Statutes at Large: Being a Collection of All the Laws of Virginia...*, 13 vols. (Richmond: Printed by and for Samuel Pleasants, 1809–23), 4:251. On the crucial role that Gooch played in campaigning for and promoting the act, see Stacy L. Lorenz, "'To Do Justice to His Majesty, the Merchant and the Planter': Governor William Gooch and the Virginia Tobacco Inspection Act of 1730," *The Virginia Magazine of History and Biography* 108, no. 4 (2000): 345–92.

31. Jacob M. Price, "The Rise of Glasgow in the Chesapeake Tobacco Trade, 1707–1775," *The William and Mary Quarterly* 11, no. 2 (1954): 179. David Daiches, as quoted in Marcus Rediker, *Between the Devil and the Deep Blue Sea: Merchant Seamen, Pirates, and the Anglo-American Maritime World, 1700–1750* (New York: Cambridge University Press, 1987), 51.

32. John Keegan, *The American Civil War: A Military History* (London: Hutchinson, 2009), 334. On tobacco as a marker of social prestige, see T. H. Breen, *Tobacco Culture: The Mentality of the Great Tidewater Planters on the Eve of Revolution* (Princeton: Princeton University Press, 1985), 71.

33. Donald E. Reynolds, "Ammunition Supply in Revolutionary Virginia," *The Virginia Magazine of History and Biography* 73, no. 1 (1965): 56–77; Jacob M. Price, *France and the Chesapeake: A History of the French Tobacco Monopoly, 1674–1791, and Its Relationship to the British and American Tobacco Trades*, 2 vols. (Ann Arbor: University of Michigan Press, 1973), 2:700–717; and William Arents, "The Seed from which Virginia Grew," *The William and Mary Quarterly* 19, no. 2 (1939): 128.

34. Curtis Putnam Nettels, *The Emergence of a National Economy, 1775–1815* (1962; repr., Armonk, NY: M. E. Sharpe, 1989), 19.

35. World Health Organization, *WHO Report on the Global Tobacco Epidemic, 2009: Implementing Smoke-free Environments* (Geneva, Switzerland: WHO Press, 2009), 8.

36. I have borrowed this notion from Michael Pollan, *The Botany of Desire: A Plant's-Eye View of the World* (New York: Random House, 2001).

37. "FAOSTAT Data-2008," Food and Agriculture Organization of the United Nations, http://faostat.fao.org/site/567/default.aspx (accessed January 4, 2010).

Further Readings on the History of Tobacco

Badger, Anthony J. *Prosperity Road: the New Deal, Tobacco, and North Carolina* (Chapel Hill: University of North Carolina Press, 1980).

Breen, T. H. *Tobacco Culture: The Mentality of the Great Tidewater Planters on the Eve of Revolution* (Princeton: Princeton University Press, 1985).

Burns, Eric. *The Smoke of the Gods: A Social History of Tobacco* (Philadelphia: Temple University Press, 2007).

Gately, Iain. *Tobacco: A Cultural History of How an Exotic Plant Seduced Civilization* (New York: Grove Press, 2001).

Gilman, Sander L., and Xun Zhou, eds. *Smoke: A Global History of Smoking* (London: Reaktion Books, 2004).

Goodman, Jordan. *Tobacco in History: The Cultures of Dependence* (New York: Routledge, 1993).

Hughes, Jason. *Learning to Smoke: Tobacco Use in the West* (Chicago: University of Chicago Press, 2003).

Kulikoff, Allan. *Tobacco and Slaves: The Development of Southern Cultures in the Chesapeake, 1680–1800* (Chapel Hill: University of North Carolina Press, 1986).

Ortiz, Fernando. *Cuban Counterpoint, Tobacco and Sugar*, trans. Harriet de Onís, 4th ed. (Durham: Duke University Press, 2003).

Winter, Joseph C., ed., *Tobacco Use by Native North Americans: Sacred Smoke and Silent Killer* (Norman: University of Oklahoma Press, 2000).

Tobacco Projects 1, 2, 3

Xu Bing

Tobacco Project collects and organizes various tobacco-related materials into something that is hard to define as either sociology or art. It began in 2000 in Durham, the home of the Duke family, then passed through Shanghai in 2004, and in 2011 continued on to Richmond, Virginia—all cities with countless ties to tobacco.

In 1999 I visited Duke University to deliver a lecture. When I entered Durham I was immediately aware of the aroma of tobacco in the air. Friends explained to me that the Duke family was built on tobacco and that Durham therefore came to be called "Tobacco City." Moreover, because the Duke University School of Medicine has excelled in treating cancer, Durham is also known as the "City of Medicine." A multifaceted connection exists between tobacco and cultural history there.

I have a habit of visiting local factories wherever I go. The "intelligent" machines I encounter there are often far more akin to art than contemporary installation work. During a visit to a cigarette factory I was drawn to the refinement of the materials, which instantly made my thinking about materials in general more sensitive and vigorous. I decided to limit myself to these materials, to create a project related to tobacco. Duke University professor Stanley Abe was very supportive of the idea. And so I began to collect and research materials and interview people with knowledge of the field and its history.

From amid the wealth of information available at the Duke University special collections library, I came to understand the historical connections between the Duke family and China, that Duke was the first person to bring cigarette-rolling technology to Shanghai. It was at this point that I decided to bring the project to Shanghai. Four years later, with the curatorial efforts of Wu Hung, *Tobacco Project: Shanghai* was realized. I created new works based on materials and sites in Shanghai, adding a dimension of historical and regional specificity to the project.

In 2006 I viewed the pipe collection of Carolyn Hsu-Balcer and René Balcer and began to learn about the history of tobacco in Virginia—a history deeply connected to the earliest settlers on the North American continent, a place that is now the manufacturing base for Philip Morris. With the support of Carolyn and René, *Tobacco Project: Duke/Shanghai/ Virginia, 1999–2011* has been realized and I have initiated an even deeper exploration of the connection between tobacco and human society.

Working checklist for the Virginia *Tobacco Project*, 2011 (cat. no. 45)

Let's analyze the question of tobacco as a fixed medium.

When I saw the refined tobacco materials at the cigarette factory, I realized that I didn't want to see these objects burned, that they could instead be used somewhere else—in art, for instance. The conception of an artwork usually begins with a sense for one's materials, the most rational relationship that exists between an artist and his or her work. I wanted to use tobacco as my primary creative medium, and it was only after this decision that questions of how and why to use these materials arose. The first step was limiting the project to materials involved in the tobacco manufacturing process. I made this choice because I knew that the field of tobacco is so abundant that one may be at a loss as to where to begin. It is important to be selective, to make that first choice that limits all further choices. Tobacco is very effective as a material because our understanding of it is fixed. In our everyday conception tobacco is a bad thing and art is a good thing. It is a notion we have come to rely upon. Thus merging the two into a single object is guaranteed to produce new outcomes. Tobacco has permeated our existence. It is something with which we are all familiar, and rarely do we look at it from a different perspective or use it in a different way. When we attempt to change our angle of approach and place tobacco within a different context, we discover an entirely new thing.

When I treat tobacco as a material and come into close contact with it, I realize that it should not be the subject of even more judgments, that it has already taken on the burden of too much social significance. I don't want my work to function as little more than a contribution to the body of tobacco-related propaganda. There is no reason for me to spend my energy saying something that everyone already knows. The value of my work lies in an intervention with tobacco unencumbered by subjective judgment. By viewing tobacco as something neutral, by returning to its innate qualities, I am simply engaging the material in a discussion, in an exchange. It is only in this interaction that one's cognitive antennae can reach out unhindered and grasp tobacco's elusive qualities. If the material is approached with a sense of moral or ethical judgment, then its true aspect will never be visible. The relationship between a work of art and its social meaning is not something that an artist should fret over, and this is particularly true with tobacco: the relationship has already been fixed by the material itself. Instead, the judgment of the artist is embodied naturally within the "motion" of the "hand." I understand my duty as similar to that of a smoker: enjoy every breath, don't worry about too much. If you worry about too much, then the cigarette will lose its flavor in the smoking.

Tobacco is intensely permeating: there is no opening that it cannot fill; its final state is ash and it touches all of us and the world around us through economics, culture, history, law, morality, belief, fashion, the space we live in, and individual interest, among many other channels. Not only is there incredible variety in the materials used to manufacture tobacco, but there is even greater variety in the limitless stream of objects and information that relate to tobacco. It makes it impossible for our project to be comprehensive. The creative process can be seen as an endless opening and reopening of Pandora's Box. For instance,

Figure 5.1
Banner for *Tobacco Project*, Duke University, 2000

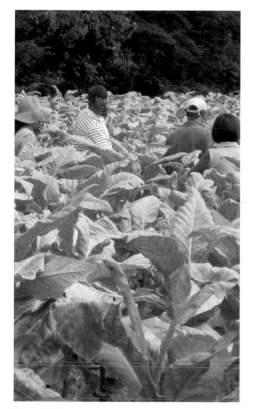

Figure 5.2
Visiting Carl Parson's farm, Chatham, Virginia, August 2009

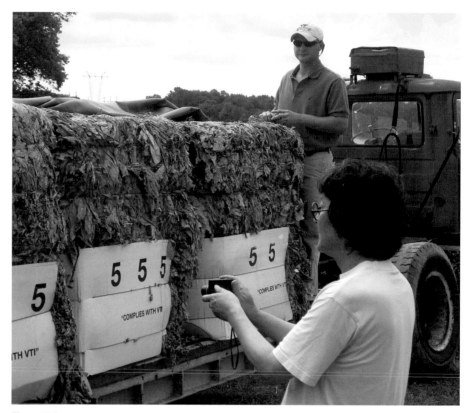

Figure 5.3
Xu Bing photographing baled tobacco at Carl Parson's farm, August 2009

in the two-year period between 1999 and 2000 when *Tobacco Project* was completed in Durham, the third wave of tobacco litigation (beginning in 1994 and centering on manipulation of nicotine levels in cigarettes) reached its height. The $145 billion Florida judgment against Philip Morris[1] changed the economic position of the American tobacco industry so much that it affected the manner in which the cigarette factories sponsoring the project worked with us. In 2004, on the eve of my trip to Shanghai, I learned that the "555" cigarette brand was close to establishing the world's second-largest tobacco production base in Ji'nan, China, a project that had only obtained Chinese government approval after twenty years of negotiation. Yet other contemporary reports quoted the Chinese government denying the story. "555" is a brand manufactured by the British American Tobacco Company, a corporation that began with Duke. Because of the difficulties facing the development of the tobacco business in the Western "First World," and because of the value and openness of China's labor market, Western tobacco companies have switched their market focus, a precise encore performance of what had transpired a hundred years earlier.

[1] Translator's note: this judgment was overturned by the Florida Supreme Court in July 2006.

Tobacco in China is state-controlled, and so it proved even more difficult to obtain materials in Shanghai than it had been four years earlier in America. Today, years later still, the legal landscape has changed dramatically in the United States for American tobacco producers, and companies were hesitant to become involved in an art project in which an exact position remains hard to pin down. At the same time, tobacco farmers and cigarette factory workers continue to feel a sense of reverence for tobacco and were eager to share their knowledge. It is a contrast that makes me even more aware of the awkward relationship that exists between tobacco and human society.

Except for taking "tobacco" as their organizing theme, the works in *Tobacco Project* share no stylistic considerations or connections. Some of the works are as small and as refined as jewelry, while some are huge and overtake the entire exhibition space. As a result of these differences, it is difficult for the audience to grasp the scope and form art should assume. The semantic effect of the project arises in the counterpoint and questioning that takes place between the various works, pushing the viewer's thinking further. In this sense tobacco's "vague uncertainty," the ambiguity of the material, is transformed into a kind of clear and vigorous language, which in turn comes to characterize the artistic language of the project.

This wide stylistic range was further informed by connections to specific sites and environments. In the first *Tobacco Project* in Durham my intention was for the project to permeate every corner of the city and penetrate the innermost memories of its residents. After all, the history of the city, of every household, and of each individual has some relationship to tobacco. In the Duke library, for instance, I filled a reading room with a variety of strange reading materials made from things tobacco-related. At the Virginia Museum of Fine Arts, *Tobacco Project* was originally scheduled for the Altria Gallery, named for the parent company of Philip Morris (although a scheduling conflict required a change to a new gallery). However most characteristic was the use of the Shanghai

Figure 5.4
Xu Bing flattening leaves for *Tobacco Book*, Richmond, February 2011

Figure 5.5
Longing, 2000

Neon, stage smoke; installation in Pack House at Duke Homestead

Dimensions variable

Neon designed and fabricated by Triangle Neon Glassworks; smoke provided by the Duke University Theatre Operations

Gallery of Art in *Tobacco Project: Shanghai*. Located on Shanghai's Bund, the gallery is a physical embodiment of the overseas corporation; it is housed in the most luxurious of Shanghai's commercial spaces; it is a place known for its "culture." The gallery employs a foreign investment strategy that can be summarized with the advertising language Duke Tobacco invoked a hundred years earlier in China, "A Civilized, Fashionable and Clean New Lifestyle." Like the early tobacco investors, earnings are made from the money Chinese people spend on a "new lifestyle."

The huge windows of the Shanghai Gallery of Art face the Pudong Development Zone, a symbol of China's economic development that includes the Lujiazui District, where Duke's British American Tobacco production base was located a hundred years ago. I utilized this fantastic site by creating a scroll of antique images depicting the district. I then painted these images onto the windows in ink. In an instant the industrial landscape of old and the living cityscape of now appeared superimposed. The hand-drawn quality of the sketch invoked a deep sense of a hunt for the traces of the past.

So in the end, what is this enormous project trying to tell us?

I am interested in an examination of inherently human issues and weaknesses through an exploration of the extensive, entangled relationship that exists between human beings and tobacco. Historically speaking, our human connection to tobacco is at times distant and at times close. In some eras tobacco is seen as something good: men and women, young and old all take part in its use. It could be said that today we have reached the summit of man's rejection of tobacco. The design of a single pack of cigarettes engages in the contradictory behavior of simultaneously promoting and rejecting its sale. Everyone knows that tobacco is harmful, but we are inseparable, caught in an entanglement that resembles the relationship between lovers: getting too close is no good, but neither is being too distant. Taken together, human weakness and the meaning of tobacco form a kind of awkward relationship, a relationship that reveals the innate human quality of self-professed helplessness. In truth, it is nearly impossible to pass judgment on the physical harm that tobacco does to us and at the same time pass judgment on all of those limitless things that we gain from within its shroud of smoke.

Tobacco Project began with an interest in the aroma of tobacco and the way it is made. The result is something enormous and growing, located between history and sociology; an activity employing artistic means to explore sociological issues or sociological means injected into art. And sometimes that's the way art arises and that's what it leads to: the sensitivity of certain people toward a certain object causing the artistic methods of the past to change while also bringing forth new ones.

May 8, 2011

(Translated by Jesse Robert Coffino)

Works in the Exhibition

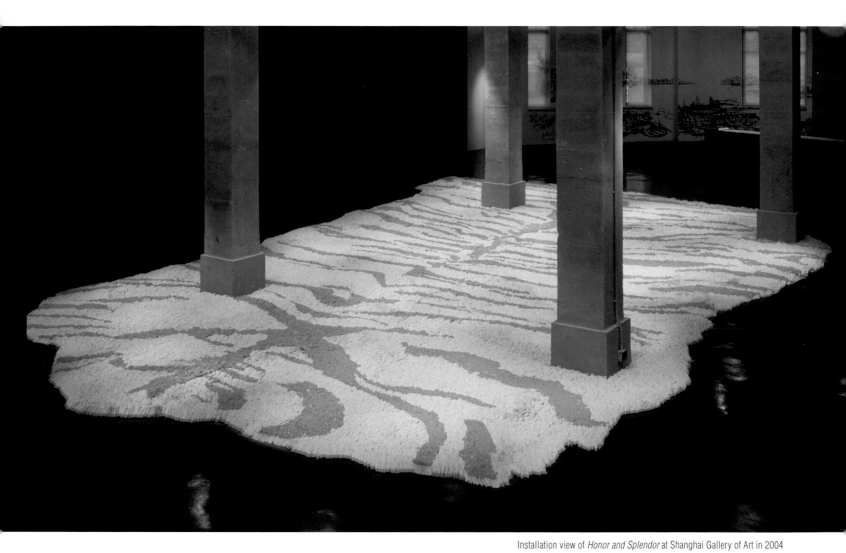

Installation view of *Honor and Splendor* at Shanghai Gallery of Art in 2004

1
1st Class
2011

500,000 "1st Class" brand cigarettes,
adhesive, carpet

Approx. 480 x 180 in. (1220 x 457 cm)

Fabrication assisted by Taylor Baldwin,
Jillian Dy, Michael Muelhaupt, Yi Sheng,
Sayaka Suzuki, Yao Xin, and numerous others

Details of 1st Class *illustrated: cover, figure
1.13, pages 68–69*

Previous version

Honor and Splendor (Shanghai version)
2004

660,000 "Wealth" brand cigarettes,
spray adhesive, cardboard

Approx. 354 x 275 in. (900 x 700 cm)

Detail of *Honor and Splendor*

2
Traveling Down the River
(Virginia version)
2011

Specially made long cigarette, burned on a reproduction of *Along the River during the Qingming Festival* by Zhang Zeduan (1085–1145)

Scroll: 501 in. (1272.5 cm)

Cigarette courtesy of Andy Shango and Mike Spissu, East Carolina RYO; Rusty Blackwell, U.S. Tobacco Cooperative; and John Taylor, U.S. Flue-Cured Tobacco Growers

Not illustrated

Previous versions

Duke version (2000)
Long uncut cigarette, burned on a reproduction of *Along the River during the Qingming Festival* by Zhang Zeduan; video loop (video by Tom Whiteside) showing the cigarette burning on the painting

Approx. 209 in. (530 cm) long

Shanghai version (2004)
Long uncut cigarette, burned on a reproduction of *Along the River during the Qingming Festival* by Zhang Zeduan

Approx. 315 in. (800 cm) long

When displayed at Duke, the scroll was partially displayed and only the visible portion was burned with a cigarette. To complete the burning, the scroll was fully extended and the remainder was burned in Shanghai.

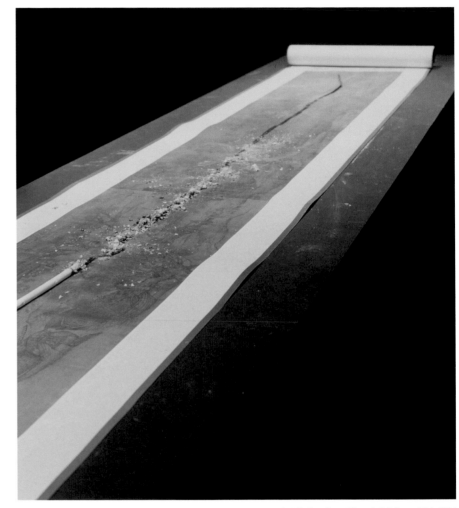

Installation view at Shanghai Gallery of Art, 2004

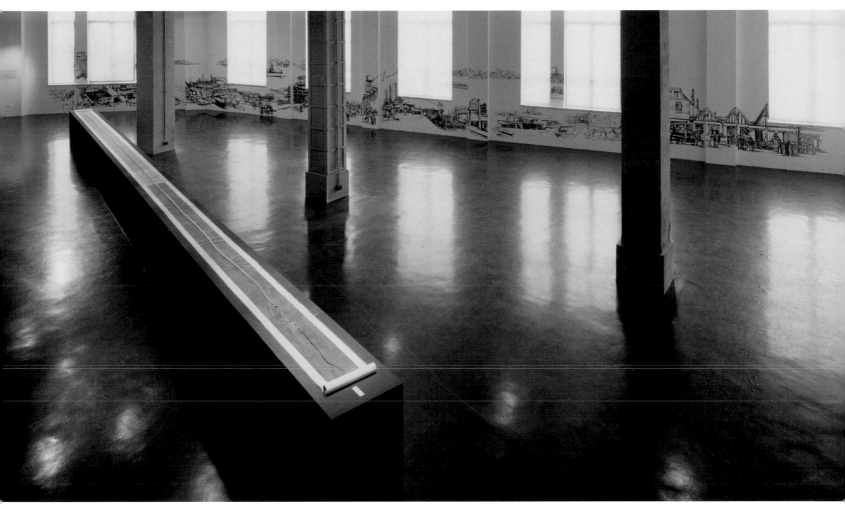

Installation view at Shanghai Gallery of Art, 2004, with *A Window Facing Pudong* in the background

Studies for
Traveling Down the River

Cat. no. 34 Cat. no. 36 Cat. no. 44

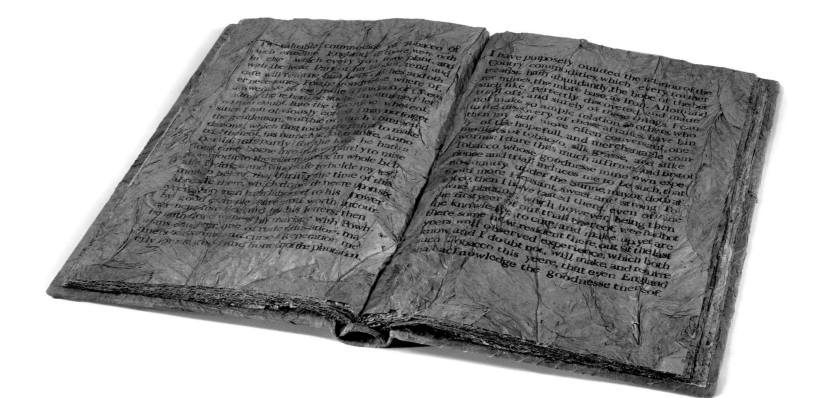

3
Tobacco Book (Virginia version)
2011

Tobacco leaves, paper, cardboard, rubber-stamped
with passage from *A True Discourse on the Present
State of Virginia* by Ralph Hamor (1615)

53 ¾ x 39 ¾ x 3 ⅞ in. (136.5 x 101 x 9.8 cm)

Tobacco leaf courtesy of Marvin Cogshill;
fabrication assisted by Jillian Dy, Yi Sheng,
Sayaka Suzuki, and Yao Xin

Previous versions

Duke version (2000)
Tobacco leaves rubber-stamped with passage
from Sherman Cochran, *Big Business in China:
Sino-Foreign Rivalry in the Cigarette Industry,
1890–1930* (1980), tobacco beetles; remains
burned in bonfire

Approx. 48 x 84 ¼ in. (122 x 214 cm)

Shanghai version (2004)
Tobacco leaves rubber-stamped with passage
from Sherman Cochran, *Big Business in China:
Sino-Foreign Rivalry in the Cigarette Industry,
1890–1930* (1980), in Chinese translation

Approx. 48 x 84 ¼ in. (122 x 214 cm)

I have purposely omitted the relation of the Contry commodities, which every former treatise hath abundantly, the hope of the better mines, the more base, as Iron, Allom and such like, Perfectly discovered, and made triall off, and surely of these things I cannot make so ample relation, as others, who in the discovery of those affaires, have bin then my self more often conversant, onely of the hopefull, and merchantable commodities of tobacco, silk grasse, and silke worms: I dare this much affirme, and first of Tobacco, whose goodnesse mine own experience and triall induces me to be such, that no country under the Sunne, may, or doth affoord more Pleasant, sweet, and strong Tobacco, then I have tasted there, even of mine owne planting, which however being then the first yeer of our triall thereof, wee had not the knowledge to cure, and make up, yet are there some now resident there, out of the last yeers well observed experience, which both know, and I doubt not, will make, and returne such Tobacco this yeere, that even England shall acknowledge the goodnesse thereof.

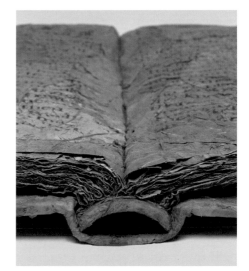

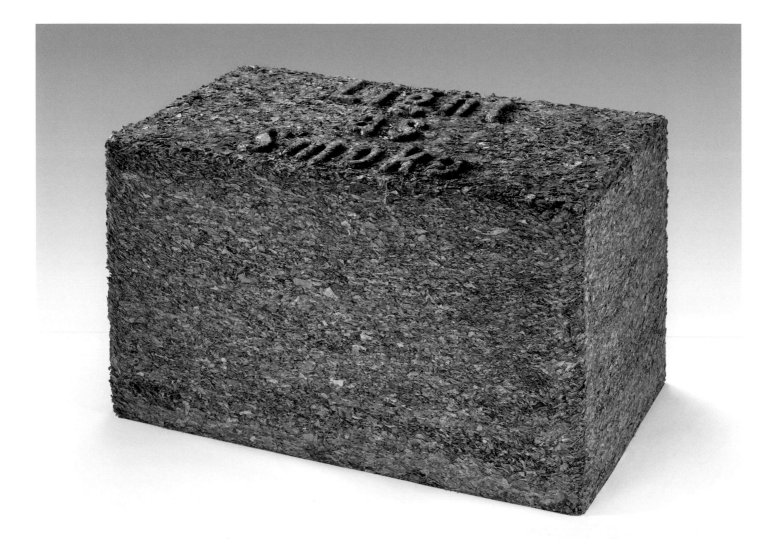

4
Light as Smoke
2011

440-lb. compressed block of tobacco with raised text:
"Light as Smoke"

26 x 43 x 26 in. (61 x 109.2 x 61 cm)

Tobacco leaf courtesy of Marvin Cogshill;
fabrication assisted by Michael Muelhaupt

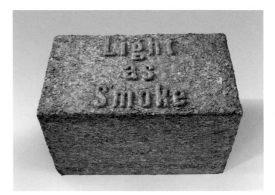

5
***Sketch for* Light as Smoke**
2011

Graphite on paper

11 x 8 ½ in. (27.9 x 21.6 cm)

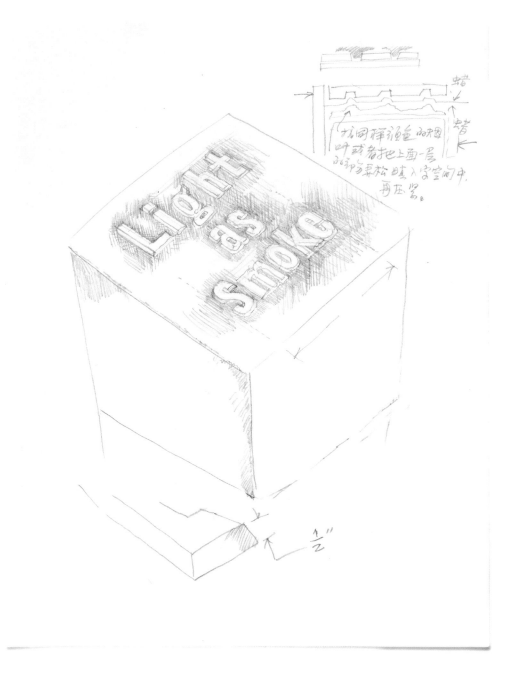

6
Match Flower (Virginia version)
2011

Branches, red match-head paste, vase
Approx. 60 in. (152 cm) high

Fabrication assisted by Andrea Donnelly

Not Illustrated

Previous version
Shanghai version (2004)
Branches, red match-head paste, vase

Approx. 70 in. (175 cm) high

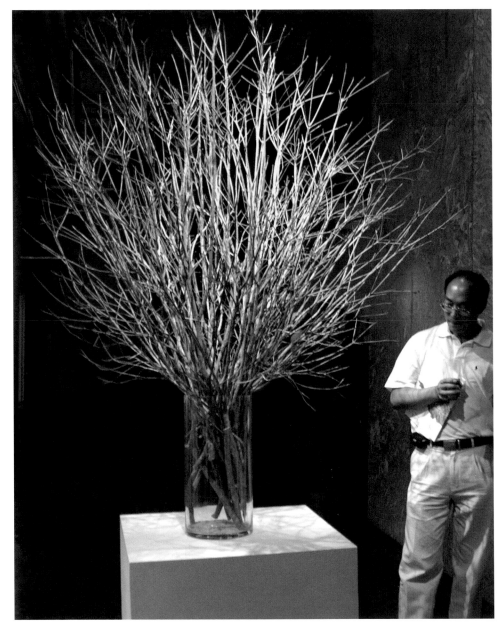

Installation view at Shanghai Gallery of Art, 2004

7
Nature's Contribution
2011

Live tobacco plants, in soil in pots

Approx. 60 in. (152 cm) high

Plants courtesy of William J. Gouldin Jr. and
William J. Gouldin III, Strange's Florists,
Greenhouses and Garden Centers, Richmond

Not Illustrated

8
Puff Choice
2011

Hinged wooden box with rubber-stamp printing, double cigarettes, foil, and five trade cards by Xu Bing

Planned edition of 18

Box (closed): ⅞ x 7 ⁹⁄₁₆ x 7 ³⁄₁₆ in. (2.2 x 19.2 x 18.3 cm)

Fabrication assisted by Amy Chan, Nicole Andreoni, Yi Sheng, and Jill Zevenbergen

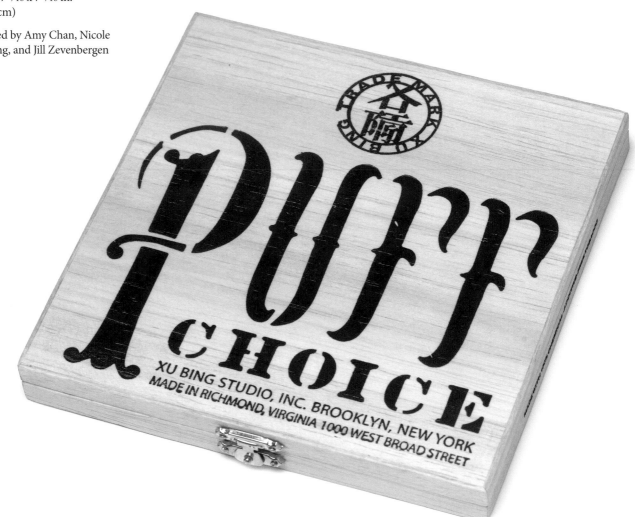

9–13
Trade cards for Puff Choice
2011

Five cards, IRIS inkjet print on paper

Planned edition of 18

6 ⅝ x 6 ⅝ in. (16.8 x 16.8 cm)

Fabrication assisted by Miriam Ewers and Yi Sheng

9

10

11

12

13

14
Backbone
2011
Made in collaboration with René Balcer

Bound book, printed in offset lithography on cigarette paper in wooden box with printed cover

11½ x 13 in. (29 x 33 cm), 158 pages

Planned edition of 18

Images courtesy of Valentine Richmond History Center; paper courtesy of Phil James, Mundet International; fabrication assisted by Laura Keller, Sayaka Suzuki, and Xu Bing Studio

Mock-up book and pages illustrated

Poem of *Backbone*

OH MY BLACK SATIN DEW DROP.

OH MY BLACK SWAN QUEEN OF THE EAST.

UB THE JEWEL OF OPHIR.

UB PURE CREAM STERLING VIRTUE.

UB ROUGH & READY PILGRIM.

OH MY LUCILLE, ALDINE, DAHLIA.

OH MY LITTLE NELL, LITTLE FLORA.

SPOT! GRAB! SNAP! CHUCK YOUR PICK!

CAMEO GOLD LEAF! CREAM OF VIRGINIA TWIST!

SWEET CHEW! BEST NAVY!

HALF ACRE!

FULL WEIGHT!

OH MY HARD PRESSED BACKBONE!

OH MY SUN-CURED SWEET PEA!

CATCH ON! BANG UP! QUICK STEP! GOT IT!

TWILIGHT…

ROCK & RYE… GOOD JOKE…

HAPPY MAN… NEW LIFE.

ALL OK.

OH MY BLACKBERRY PRINCESS.

OH MY DEEP CREEK CUSTARD PIE.

OH MY HONEY CHUNK SURPRISE.

UNO LEGAL TENDER.

UNO PLANTERS CHOICE.

UNO STEREOTYPE.

UB DEFIANCE!

UB PERFECTION!

UB MY DELIGHT!

UB ABOVE ALL INVINCIBLE.

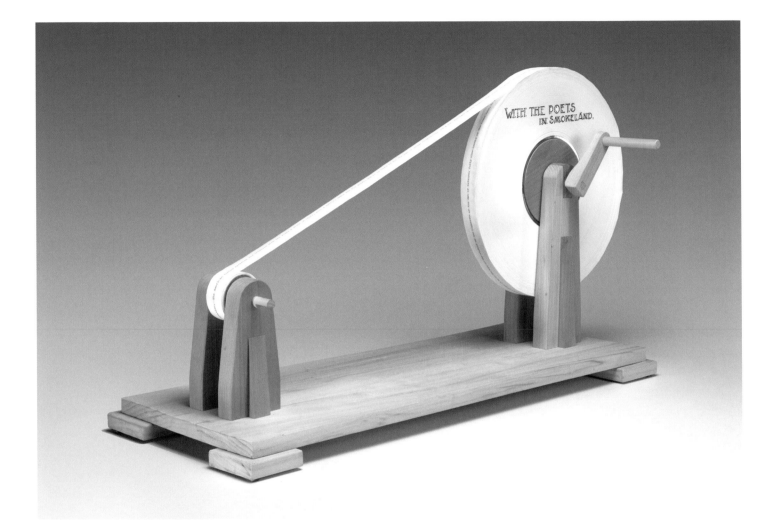

15
Reel Book
2000; modified in 2011

Roll of 1 1/16 in.–wide uncut cigarette paper, typed with text from *With the Poets in Smokeland* (1875–90), wooden crank mechanism

Approx. 24 1/8 x 29 7/8 x 12 in. (61 x 76 x 30.5 cm)

Paper courtesy of Phil James, Mundet International; typing by Andrea Donnely; crank mechanism fabricated by Brad Johnson, Harvey Craig, and Alan Dippy, courtesy of the Duke University Museum of Art; rubber stamp by Jill Zevenbergen

When displayed at Duke University in 2000, text from Robert F. Durden, *The Dukes of Durham* (1975) was used.

16
Production drawing for
Reel Book
1999

Graphite on paper

8 $\frac{1}{2}$ x 11 in. (21.6 x 27.9 cm)

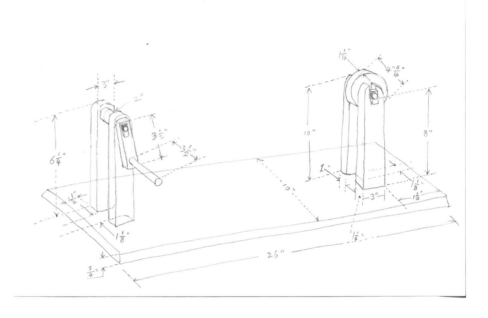

17
Chinese Spirit
2000

Hinged balsa box printed in English and *Square Word Calligraphy*, "American Spirit" brand uncut double cigarettes, foil, and three trade cards

Box (closed): 4 ½ x 7 ½ in. (11.5 x 18.5 cm)

Cigarettes courtesy of Michael Little, Santa Fe Natural Tobacco Company; fabrication of wooden boxes assisted by Brad Johnson, Harvey Craig, and Alan Dippy, courtesy of the Duke University Museum of Art

18
***Sketch for** Chinese Spirit*
lid graphics
1999

Ink, graphite on paper

11 x 8 ½ in. (27.9 x 21.6 cm)

19–21
Trade Cards for Chinese Spirit
2000

Three cards, ink on paper, with adapted
early-twentieth-century design

Each: 6 ½ x 4 in. (16.5 x 10.3 cm)

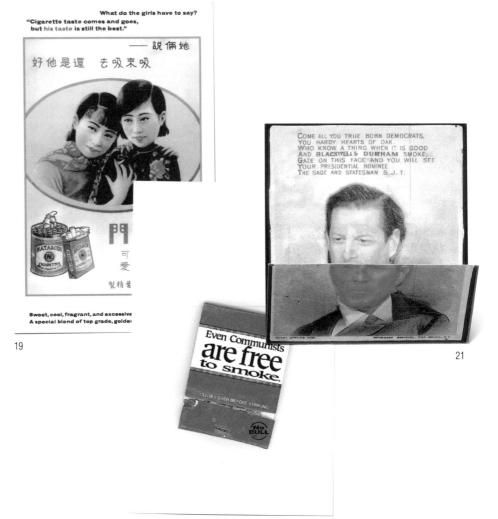

19

20

21

Folded

Unfolded

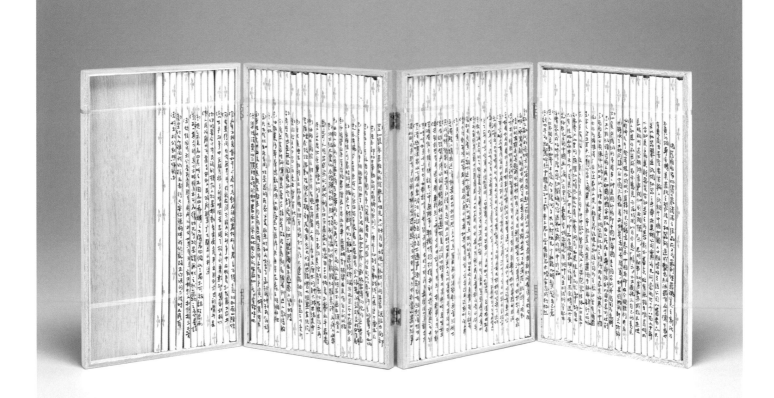

22
Miscellaneous Book
2000

Custom-cut "American Spirit" brand cigarettes, Chinese texts from *Daodejing* and Chairman Mao's words handwritten in ink, encased in hinged wooden box

Box (closed): 12 x 7 ⅞ x 2 in. (30.5 x 20 x 5 cm

Cigarettes courtesy of Michael Little, Santa Fe Natural Tobacco Company; fabrication of wooden boxes assisted by Brad Johnson, Harvey Craig, and Alan Dippy, courtesy of the Duke University Museum of Art

23
Sketch for Miscellaneous Book *and* Notebook
1999

Ink, graphite on paper

11 x 8 ½ in. (27.9 x 21.6 cm)

24
Pipe
2004; seventh stem added in 2011

Wood tobacco pipe with six added stems and tobacco

3 ³⁄₈ x 12 ¼ x 10 ½ in. (8.6 x 31 x 26.7 cm)

Fabrication assisted by Michael Muelhaupt

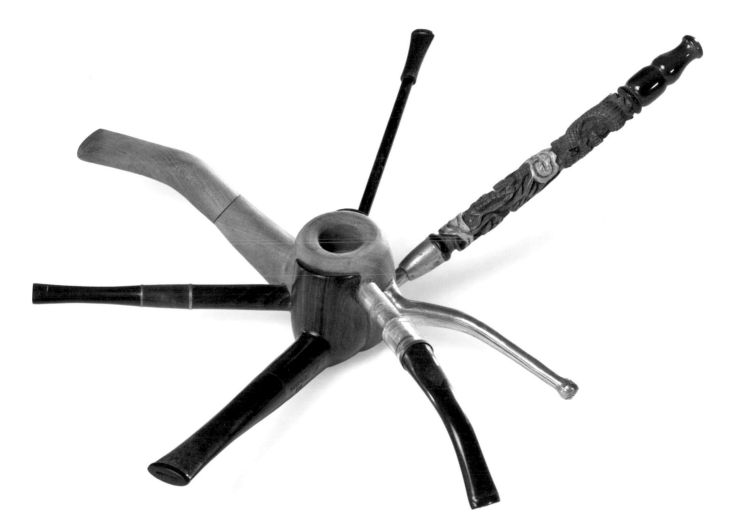

25
Redbook
2000

"Zhonghua" brand cigarettes, rubber-stamped with various English texts from *Quotations by Chairman Mao* (Little Red Book), original metal case

Case (closed): 3 ½ x 3 ⅞ in. (9 x 10 cm)

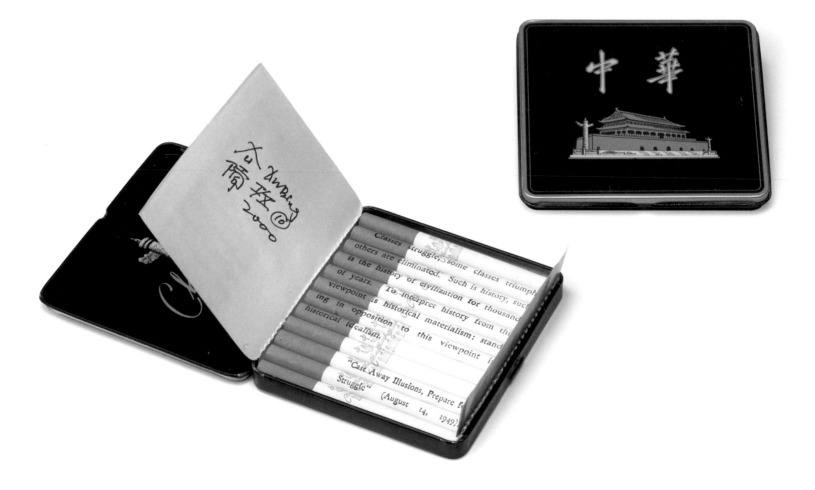

26
Tang Poems
2000

Accordion books made of cigarette filter
"tipping" paper, typed with English translations
of Tang poems

Each (closed): 2 x 2 ⅜ in. (5 x 6 cm)

Typing by Kwong Li and Nicole Hess; "tipping"
paper courtesy of Michael Little, Santa Fe
Natural Tobacco Company

27
Calendar Book
2000

"American Spirit" brand cigarette boxes, artist's father's medical records, plastic desk calendar frame, double cigarette

4 ⅞ x 7 ½ in. (12.5 x 19 cm)

Fabrication assisted by Jason Wagner

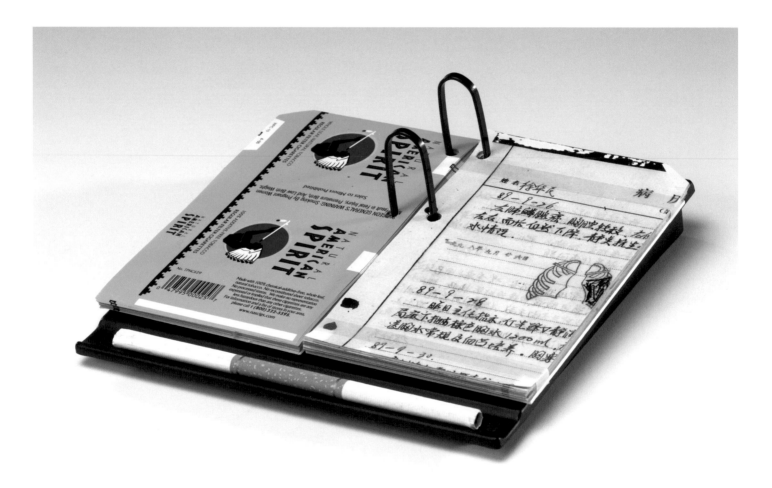

28
Match Book
2000

Cardboard matches, printed with lines from
Robert Frost's "Fire and Ice" (1920)

Each: 1 ⅝ x 1 ¾ in. (4 x 4.5 cm)

Matchbooks courtesy of Michael Little, Santa Fe
Natural Tobacco Company

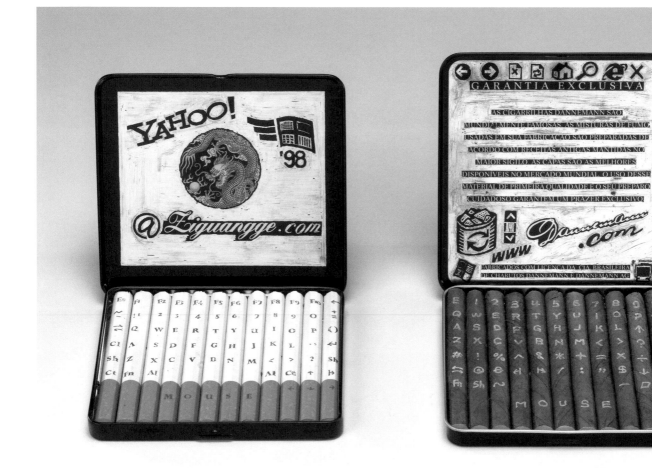

29
Notebook
2000

"Zhonghua" brand cigarettes, rubber-stamped
with computer keyboard characters, original metal
case with lid interior selectively scratched off to
create computer logos

Case (closed): 3 ½ x 3 ⅞ in. (9 x 10 cm)

30
Notebook
2004

"Dannemann" brand cigarillos, rubber-stamped
with computer keyboard characters, original metal
case with lid interior selectively scratched off to
create computer logos

Case (closed): 3 ½ x 3 ⅞ in. (9 x 10 cm)

31
Untitled small work
2004

121 "Zhong Nanhai" brand cigarettes, acrylic box
3 ¾ x 3 ½ x 3 ½ in. (9.5 x 9 x 9 cm)

32
Untitled small work
2004

Ceramic ashtray, paint
1 ⅛ x 3 ½ x 3 ½ in. (3 x 9 x 9 cm)

33
*Artist's father's
medical records*
1989

Ink on paper, envelope

Each: 10 ¼ x 8 ⅛ in. (26 x 20.5 cm)

34
Study for Traveling Down the River
1999

Red and black ink on paper with cigarette and burn mark

11 x 8 ½ in. (27.9 x 21.6 cm)

35
Sketch for
Traveling Down the River
and other works
1999

Graphite, red ink on paper

11 x 8 ½ in. (27.9 x 21.6 cm)

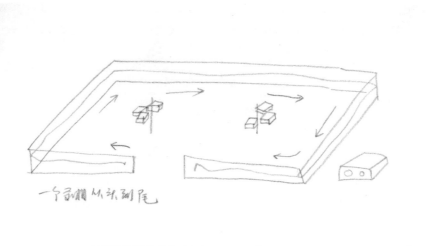

一个部撒从头到尾

这是在一张清明上河图上

这是在一个色彩鲜艳的风景上

或个手提电脑

这我可用在
毛国代场中

色上一个录相

1881岁一个意书图机出现
Duke毛先泡给梅个地图,他把高中国况标机
吉边(界中国岛大450,000,000人口,他计划每人一毛
一呈书图.全新钱.无标机好到1716岁一到采3,12,000,000,000呈书图

正顶邮宣使更
地图如100个苦闷

36
Study for
Traveling Down the River
1999

Pencil on paper with gold foil cigarette
packaging and cigarette burn mark

11 x 8 ½ in. (27.9 x 21.6 cm)

37–38
Production drawings for
Chinese Spirit
1999

Graphite on paper

Each 8 ½ x 11 in. (21.6 x 27.9 cm)

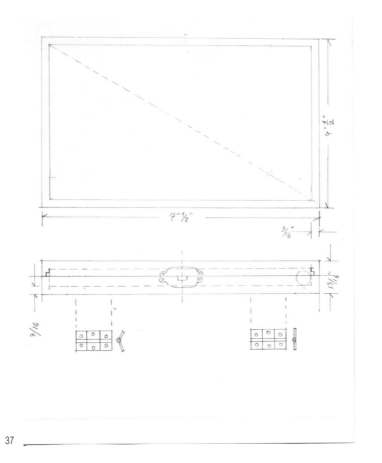

37

38

39–40
Sketches for Chinese Spirit *trade cards*
1999

Graphite on photocopy paper

11 x 8 ½ in. (27.9 x 21.6 cm)

39

40

41
Sketch for unrealized work
1999

Graphite, box of "Rizla" rolling papers, rolling paper with ink, printed cigarette package seals, two rolling papers with graphite

11 x 8 ½ in. (27.9 x 21.6 cm)

42
**Production drawing for
Miscellaneous Book**
1999

Graphite on paper

11 x 8 ½ in. (27.9 x 21.6 cm)

44
**Study for
Traveling Down the River**
1999

Burned cigarette, staples, graphite on burned paper

11 x 8 ½ in. (27.9 x 21.6 cm)

Illustrated on page 8

43
**Sketch for untitled
small work** (cat. no. 31)
2004

Graphite on paper

11 x 8 ½ in. (27.9 x 21.6 cm)

45
**Working checklist for the
Virginia Tobacco Project**
2011

Ink, graphite on paper

11 x 8 ½ in. (27.9 x 21.6 cm)

Illustrated on page 62

Artist's Biography

Xu Bing was born in Chongqing, China, in 1955. His family roots go back to Wenling, Zhejiang Province. In 1977 he entered the printmaking department of the Central Academy of Fine Arts, Beijing (CAFA), where he completed his bachelor's degree in 1981 and stayed on as an instructor, earning his MFA in 1987. In 1990, on the invitation of the University of Wisconsin-Madison, he came to the United States and then settled in New York. In 2007 he returned to Beijing to serve as the vice president of CAFA.

Solo exhibitions of Xu Bing's work have been held at Joan Miró Foundation, Mallorca, Spain (1997), New Museum of Contemporary Art, New York (1998), National Gallery of Prague (2000), Arthur M. Sackler Gallery, Smithsonian Institution, Washington, D.C. (2001), and Spencer Museum of Art, Kansas (2007), among other major institutions. Additionally, Xu Bing has shown at the 45th and 54st Venice Biennale (1993 and 2011), the 2nd Johannesburg Biennale (1997), and Biennale of Sydney 2000, among other major international exhibitions.

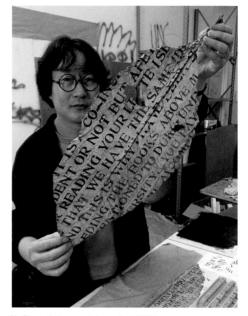

Xu Bing printing on a tobacco leaf, 2000

As an artist and educator, Xu Bing has received many honors. In 1990 he received the Huo Yingdong Education Foundation Award from the China National Education Association for his contribution to art education. In 1999 he was a recipient of the John D. and Catherine T. MacArthur Fellowship to honor his "capacity to contribute importantly to society, particularly in printmaking and calligraphy." In 2006 the Southern Graphics Council awarded Xu Bing their lifetime achievement award in recognition of the fact that his "use of text, language, and books has impacted the dialogue of the print and art worlds in significant ways."

Over the years, Xu Bing's work has appeared in high-school and college textbooks around the world, including *Art Past, Art Present* (Abrams, 1997), *Gardner's Art through the Ages* (11th edition, 2001), and Craig Clunas's *Art in China* in the Oxford History of Art series (1997). In addition to numerous solo exhibition catalogues, a few major monographic studies have been published. In 2006, Princeton University Press issued *Persistence/Transformation: Text as Image in the Art of Xu Bing*, a multidisciplinary study of the artist's early signature work *Book from the Sky*, edited by Jerome Silbergeld and Dora C. Y. Ching. *Tianshu: Passages in the Making of a Book* is another detailed study of the same work, edited by Katherine Spears and issued by London bookseller Bernard Quaritch in 2009. An extensive study of the artist's oeuvre has been made in *Xu Bing*, a multi-author book of 2011, issued by London's Albion Editions and distributed in the United States by D.A.P. This volume includes a comprehensive exhibition history and bibliography.

Appendix

Works in *Tobacco Project*, Duke/Shanghai/Virginia, 1999–2011

Tobacco Project, Duke (2000)

Artist's father's medical records
Calendar Book
Chinese Spirit
Daodejing
Fact
Longing
Match Book
Miscellaneous Book
Notebook (2000)
Redbook
Reel Book
Re-type Book
Tang Poems
Tobacco Book (Duke version)
Tobacco Questionnaires
Traveling Down the River (Duke version)

Tobacco Project, Shanghai (2004)

Works created for Shanghai
Honor and Splendor
The Invention of Tobacco
Match Flower (Shanghai version)
Notebook (2004)
Pipe
Prophecy
Rounding Up/Rounding Down
Tobacco Book (Shanghai version)
Traveling Down the River (Shanghai version)
Untitled small work (acrylic box)
Untitled small work (ashtray)
A Window Facing Pudong

Works from the Duke exhibition
Artist's father's medical records
Chinese Spirit
Daodejing
Match Book
Miscellaneous Book
Notebook (2000)
Redbook
Reel Book
Re-type Book
Tang Poems
Tobacco Questionnaires (questionnaires only)

Tobacco Project, Virginia (2011)

Works created for Virginia
Backbone
1st Class
Light as Smoke
Match Flower (Virginia version)
Nature's Contribution
Pipe (stem added)
Puff Choice
Reel Book (modified)
Tobacco Book (Virginia version)
Traveling Down the River (Virginia version)

Works from the Shanghai exhibition
Notebook (2004)
untitled small work (acrylic box)
untitled small work (ashtray)

Works from the Duke exhibition
Artist's father's medical records
Calendar Book
Chinese Spirit
Match Book
Miscellaneous Book
Notebook (2000)
Red Book
Tang Poems

Notes

These lists exclude studies and other preparatory drawings. Parenthetical notations are given to 1) different iterations of the same work (e.g., three versions of *Tobacco Book*); 2) different works under the same title; and 3) works subsequently altered.

Index

Pages containing illustrations are given in **bold**.